The Angel Roofs of East Anglia

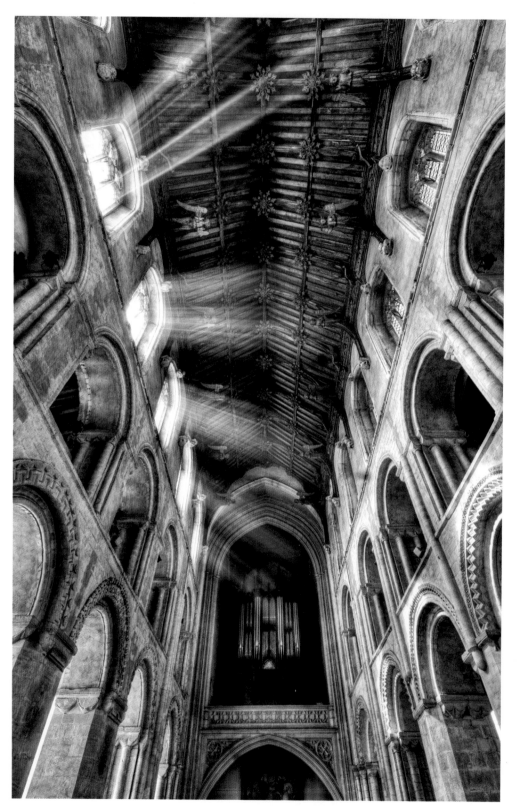

The angel roof at Wymondham Abbey, Wymondham, Norfolk.

The Angel Roofs of East Anglia

Unseen Masterpieces of the Middle Ages

Michael Rimmer

The Lutterworth Press

The Lutterworth Press
P.O. Box 60
Cambridge
CB1 2NT
United Kingdom

www.lutterworth.com
publishing@lutterworth.com

ISBN: 978 0 7188 9369 9

British Library Cataloguing in Publication Data
A record is available from the British Library

First Published, 2015

The maps in this book were created using
the myPhotoMap app (www.mytracks4mac.com)
and Open Street Map (www.openstreetmap.com).

For Beata, John and Geraldine
and for the soul of the Methwold Master

Nowhere outside England can be found such a series of magnificent timber roofs as those of which Westminster Hall, Hampton Court and the angel roofs of East Anglia are examples.

L.F. Salzman
Building in England (1952)

The East Anglian group includes very many fine roofs, in which the length of the wall posts and the common use of the hammer-beam are the most striking features. The timbers are generally very light, and the curves of the braces are wrought with much refinement and sense of proportion. The construction is more daring, the effect lighter and more graceful, than in any other part of the country, and the architectural details of traceried and foliaged spandrels, moulded timbers, and battlemented or crested cornices are usually far more elegant. Moreover, a lovely effect is produced in very many roofs by poising carved angels with widespread wings on every point of vantage.

F.E. Howard and F.H. Crossley
English Church Woodwork (1917)

If you envision the forces of gravity and weather acting on one of the trusses, the whole elaborate structure comes to life. Force rolls down the great composite rafters. . . . More force flows straight down from the roof peak into the king post, which in turn distributes its forces to the queen posts and they to the collar beam. . . . Force flows off the building into the ground through the top of the wall and through wall posts and corbels.

William Bryant Logan
Oak: the Frame of Civilization (2005)

THE CHURCHES
CONSERVATION TRUST

The national charity protecting historic churches at risk.

The Churches Conservation Trust has saved over 345 beautiful buildings
which attract almost 2 million visitors a year.

Its unique collection of historic churches is the largest in the country, featuring treasures
ranging from virtually untouched medieval gems in idyllic rural settings to ornately
impressive Victorian masterpieces in busy urban centres. All are of international
importance and include irreplaceable examples of architecture,
archaeology and art from 1,000 years of history.

All royalties from the sale of this book will be donated to
The Churches Conservation Trust in support of its work.

Contents

List of Illustrations

Unless otherwise stated, the photographer and copyright holder of all images listed below is the author, Michael Rimmer.

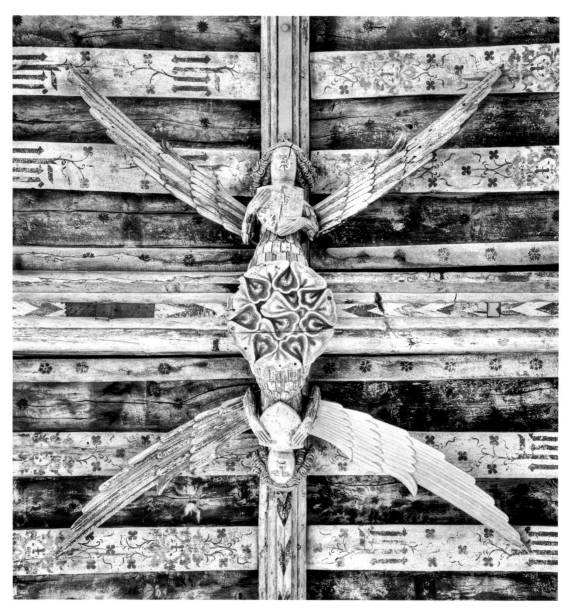

*Paired angels on the central beam of the cambered roof
at Holy Trinity, Blythburgh, Suffolk (see pp. 74–5).*

Foreword

Before any visit to a historic church, habit leads me to start with Pevsner, whose deadpan description of the roof of St Nicholas, King's Lynn, reads, "The roof has tie-beams on shallow arched braces with traceried spandrels. Above the tie-beams tracery and arched queenposts, also with tracery . . . each alternating truss has angels as hammerbeams." There is little there to indicate that St Nicholas' angel roof is a miracle of English carpentry, one of many such to be found throughout East Anglia where the genre flourished from the late 1390s until the 1530s, at which point the artistically deadening hand of Reformation began to sweep away religious imagery. Amidst the turbulent iconoclasm of the Reformation years, when so much ecclesiastical art and decoration was defaced and destroyed, most angel roofs survived, protected by their inaccessibility. Of the almost 170 surviving angel roofs in England and Wales, roughly 70 per cent can be found in Norfolk, Suffolk and Cambridgeshire. The same inaccessibility that protected these roofs has also made them hard to appreciate without the aid of binoculars and the resulting consequence of a stiff neck. This book is of great importance because Michael Rimmer, a keen photographer and connoisseur of angel roofs, has succeeded in documenting virtually every surviving medieval angel roof in East Anglia. Thanks to scaffolding in churches under restoration, I have been privileged enough to get up close to an angel roof a few times. Now thanks to Michael's photographs, that experience is available to many for whom these photographs will be a revelation, showing the complex mix of carpentry, engineering, artistry and faith that make these roofs so thrilling to contemplate.

I have the honour of being Chairman of The Churches Conservation Trust; St Nicholas, King's Lynn, with its angel roof, is among the nearly 350 churches we care for. I believe they all have the power to galvanize communities and inspire and delight individuals. With a generosity to match his talent, Michael has kindly decided to donate his royalties from this book to The Churches Conservation Trust and all lovers of the English parish church should be grateful to him.

Loyd Grossman
Chairman of The Churches Conservation Trust

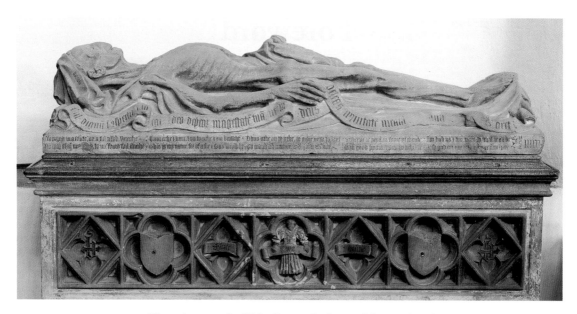

The cadaver tomb of John Baret, the donor of the angel roof
at St Mary, Bury St Edmunds, Suffolk (see p. 76).

Note on the Scope of the Book

THE SCOPE OF THIS BOOK is confined to medieval angel roofs, that is those built between the mid-1390s (the date of the first known angel roof), and the onset of the Reformation. A number of angel roofs – inspired by and emulating medieval fashion – were built in the Gothic revival of the Victorian and Edwardian periods. Examples of these include Booton in Norfolk and Eye, Huntingfield, Elveden and St Edmundsbury cathedral in Suffolk. Such post-medieval angel roofs do not feature here, though that at Huntingfield is mentioned, in passing, with reference to the use of colour in medieval roofs.

Acknowledgements

I WOULD LIKE TO THANK all those who have provided help, advice and encouragement in my study of angel roofs, particularly Professor John Onians, Professor Sandy Heslop, Dr Margit Thofner, Dr Claire Daunton and Mr Michael Begley. All errors are entirely my own.

My thanks also to Liz Truss MP, Steve Stockwell and Lt Col E. Lloyd-Jukes for enabling me to photograph the angel roof at Westminster Hall.

I am grateful to all those churches that offer open visitor access, and to the key holders who have taken the time and trouble to let me in to those that are usually locked.

Finally, I would like to acknowledge the unstinting hard work, expertise and support of my editors at The Lutterworth Press, Lisa Sinclair and Bethany Churchard. It has been a pleasure to work with them.

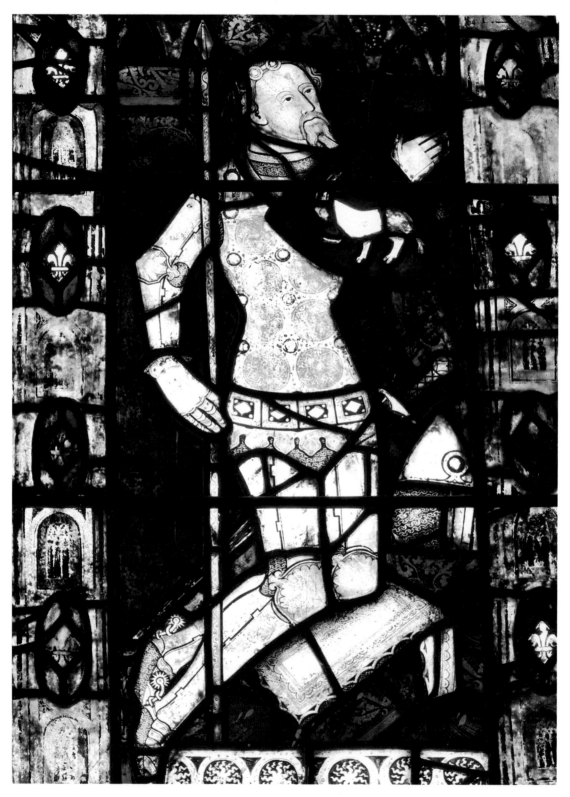

A stained glass window depicting Sir William de Bardwell, the likely donor of the angel roof at St Peter and St Paul, Bardwell, Suffolk (see p. 13).

Heaven in the Rafters
A Historical Consideration of Angel Roofs

What Are Angel Roofs?

B Y THE LATE 1300S, English struc-
tural and decorative woodworking had
attained an outstanding level of skill
and sophistication. The angel roof is one of the
most impressive and complex examples of this
skill. The hammer beam roof is another. In East
Anglia, the two structures often combine, but
rarely anywhere else in the country.

Between 1395 and the beginning of the
Reformation in the 1530s, several hundred angel
roofs were built in England, most of them during
the 1400s, a century of usurpation, conquest and
loss in France, the Wars of the Roses and the
birth of the Tudor dynasty. Of these medieval
angel roofs, over 170 survive (this total includes
some that have been defaced or where the
angels have been removed). They occur almost
exclusively in churches, and predominantly
in East Anglia, particularly in the counties of
Norfolk and Suffolk.

Angel roofs are found in a range of structural
patterns, but whatever their form, they are all, by
definition, adorned with carved images of angels.
In some churches, the angel figures are over 6 feet
tall; in others, the carvings are half-body figures or
smaller low-relief carved plaques. In some roofs,
only a handful of angels remain, elsewhere dozens,
while a few contain over 100 winged carvings.

Because they are inaccessible, often literally
obscure, immovable and challenging to photo-
graph, angel roofs have been almost completely
neglected by academics and art historians. This
book is a first attempt to redress that neglect, and
to bring the beauty and craftsmanship of these
remote medieval creations – which are often
masterpieces of both medieval sculpture and
timber engineering – to a wider audience.

Why Do Angel Roofs Matter?

There are an estimated 9000 medieval churches
in England.[1] Today, most are largely devoid
of medieval images. The walls are generally
whitewashed or stripped back to bare stone.
Most of the glass will be clear, or, if stained,
predominantly Victorian. There will be little
statuary, and such statues as there are will be
post-medieval. There will often be no altar
screen dividing the nave from the chancel, and
the chancel arch itself will be empty.

So sparse and monochrome an interior would
be unrecognizable to the medieval worshipper.
Until the Reformation swept such things away,
England's churches blazed with colour and
were filled with didactic and devotional images.
Medieval religion was intensely visual – it had to
be; many of the faithful could not read, and even
for those who could, manuscript books were rare
and expensive objects. The first *printed* Bible in
English, Tyndale's version of the New Testament,
was not published until 1526, less than twenty
years before Henry VIII's break from Rome.

As a result, visual imagery played a huge part
in conveying the messages of religion. Wall
paintings told the stories of saints, depicted
the Saviour and warned against the vices.
Graphic "Dooms" – paintings of Judgment
Day – illustrated the rewards of piety and the

hellish penalties of sin.[2] Stained glass blazed with angels, saints and the Holy Family; niches and altars held polychromed devotional statues; and painted altar screens glowed with images of saints, angels and apostles.

There were chantry chapels, where Masses were given for the souls of the wealthy departed; guild altars, at which medieval trade bodies honoured their patron saints; and Easter sepulchres − carved representations of Christ's tomb − which became a focal point for vigils and dramatic re-enactments in Holy Week. Above all, in every church in the land, set high in the chancel arch, the rood − a sculptural depiction of Christ crucified, flanked by the Virgin Mary and St John − towered above the congregation as a constant reminder of Christ's sacrifice and the coming Judgment.

In 1534, England changed forever. Henry VIII broke with Rome and established a new state religion with the king, not the Pope, at its head. A religious revolution was underway, and over the decades that followed, it unleashed a tidal wave of iconoclasm, as the new religion obliterated the visual images of the old − now seen as discredited, idolatrous distractions − and replaced them with a new emphasis on scripture.

The Dissolution of the Monasteries, themselves treasure houses of medieval religious art, and the destruction of venerated pilgrimage statues under Henry VIII in the 1530s was merely the beginning. Henry's successor, Edward VI (1547-53), raised in the Protestant religion and surrounded by radical Protestant counsellors, widened and intensified the attack on religious images. Wall paintings were whitewashed over, statues smashed and rood sculptures torn down, and even stained glass became a target for the reformers. The process continued under Elizabeth I (1558-1603) and then resurfaced in a vicious second wave during the English Civil War (1642-51) as Puritan radicals (targeting glass, bench ends, inscriptions and remaining sculptures) renewed the attack.

It has been estimated that by the late 1640s, more than 90 per cent of English medieval religious imagery had been destroyed. Such medieval figurative art as remains today in English churches is the minutest tip of a lost iceberg of sculpture, painting and stained glass.[3] The English Reformation was not just a religious revolution. It was an artistic holocaust.

In the words of Professor Phillip Lindley, "Iconoclasm . . . reduced the brightly-painted, image-encrusted churches of medieval Britain to white or grey boxes in which a purified religion could be safely preached and read. And it . . . resulted in the destruction of almost the entire output of medieval religious sculpture in Britain."[4]

But amidst this destruction, one category of medieval religious sculpture suffered much less harshly. Roof angels were far above the ground, inaccessible and sometimes actually supporting the church roof. Many still succumbed to the iconoclasts, but to tear roof angels down required determination, time and the co-operation of locals, and these were not always available. (By contrast, most stained glass was a sitting duck, which is why so many medieval churches today have only clear glass or Victorian replacements.)

Simply because they were hard for Reformation image destroyers to reach, roof angels are now the largest surviving body of major English medieval wood sculpture. High up in darkness or extremes of light and shade, they are often overlooked by visitors, but these remarkable and beautiful structures testify to the skill and vision of medieval carvers and carpenters, and they have much to tell us about the beliefs, economics and power structures of medieval England.

Where Are Angel Roofs Found?

Almost 170 medieval angel roofs survive in England and Wales (including those that have been defaced or where the angels have been removed). All but a handful are in parish churches.[5]

Nearly 70 per cent of the surviving total is in East Anglia, which is traditionally defined as the three counties of Norfolk (26 per cent), Suffolk (29 per cent) and Cambridgeshire (14 per cent). A further 14 per cent are in counties that border the region (Lincolnshire, Bedfordshire, Essex, Hertfordshire and Northamptonshire). Angel roofs are thus an overwhelmingly East Anglian and eastern counties phenomenon.

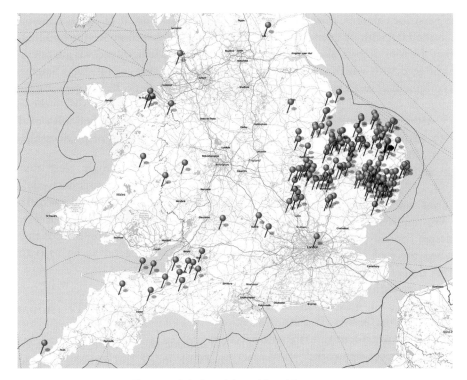

Figure 1: Medieval Angel Roof Locations

Appendix 1 provides detailed location maps for Norfolk, Suffolk and Cambridgeshire, and a gazetteer.

There are small pockets of angel roofs elsewhere, notably in Wales, Somerset and Devon, but these are very different in design to the angel roofs of the eastern counties, and would seem to have developed separately.[6]

The above map raises the following question: why are angel roofs so curiously specific to East Anglia? Academics and art historians have advanced a range of theories, none of them entirely convincing. We will return to this question shortly.

The First Angel Roof

The earliest known angel roof is not in East Anglia, but in London, at Westminster Hall, now part of the Houses of Parliament.

Built mainly between 1393 and 1398, this colossal oak roof is the crowning achievement of Hugh Herland, master carpenter to Richard II. It was installed as part of the enlargement

and restoration of the Hall for this most image-conscious king.[7]

Westminster Hall's is both the first known angel roof and the earliest surviving major hammer beam roof.[8] The architectural historian John Harvey described it as "the single greatest work of art of the whole of the European Middle Ages. No such combined achievement in the fields of mechanics and aesthetics remains elsewhere, nor is there any evidence for such a feat having ever existed."[9]

68 feet wide, 240 feet long and 92 feet high, bridging a span previously unprecedented in England, Herland's roof features thirteen pairs of hammer beams carved into the form of angels, each of which bears the royal arms of Richard II. The angels project horizontally from the wall plates, intersecting huge arch ribs and stretching beyond to support vertical hammer posts which again connect with the curved ribs higher up.

A staggering masterpiece of art and engineering, Herland's roof uses this interlocking combination of colossal timber arches and gargantuan hammer beams to provide rigidity

without the need for columns, thus leaving the floor space in the Hall entirely open. It has been estimated that the roof timbers alone weigh 660 tons, while the lead with which the exterior of the roof was originally covered weighed a further 176 tons.[10]

In an age without constructional physics or the ability to perform complex mathematical calculation, medieval roof-engineering was an empirical and risky business, and one that often entailed a high degree of redundancy as carpenters erred on the side of caution. This is true at Westminster, where the beauty of Herland's design conceals enormous robustness. By 1914, when the roof was restored, over 70 per cent of its timbers were found to be rotten due to attack from deathwatch beetles. Cavities large enough to hold a full-grown man had been eaten into some of the beams. That the roof still functioned is testament to the strength of Herland's "belt and braces" approach.[11]

> The medieval carpenter did what today's engineer might call "overbuilding." The carpenter called it sound, sensible, right, proper. The carpenter's knowledge came from what he put his hands on, and from materials that he knew both in the woodland and in his yard. . . . He had a deep visual imagination of the way forces act. . . . For the carpenter, prudence, not economy, was the first virtue. He made redundant systems intentionally, much as the oak tree does with its dormant buds and its hundreds of miles of roots. A failure of one piece will not bring the whole thing down.[12]

Even today, with the benefit of computer modelling and pressure sensors, architectural experts disagree on exactly *how* Herland's roof works, but its strength is clearly based on the combination of arches (arch ribs) and braced right-angles (hammer posts and hammer beams), with point load further dispersed through vertical tracery (spandrels). These and related structural techniques were subsequently deployed in many of the angel roofs of East Anglia.

Though we marvel at the expertise of craftsmen whose buildings still stand 600 years or more after their completion, it is worth remembering that we do, of course, only see the buildings that have succeeded. Medieval records are full of references to structures that collapsed. As Salzman observes in his great work *Building in England* (1952), jerry-building is not exclusive to the modern era. Inevitably we view the buildings of the Middle Ages through the lens of survivorship bias.

> . . . it is refreshingly clear that if the medieval craftsman-architect could create masterpieces, he could make as bad blunders as any of his desk-bound successors; and that if the British workman of the present day is not as good as he used to be, he probably never was.[13]

Why Angels at Westminster?

Who made the decision to adorn Westminster roof with angels, and in doing so apparently gave birth to an entire genre of medieval roof design, is not known. It may have been Richard II himself. There is certainly much evidence that angels played a prominent part in the iconography of his regime, as the king sought to establish a more absolutist, non-consultative form of monarchy than had previously been seen in England.

The *Wilton Diptych*, a portable altar screen made in the 1390s for the king's private devotions (now in the National Gallery, London), shows Richard being presented by saints to the Virgin and Child, who are flanked by eleven angels wearing his livery badge of a chained white hart.

Angels also featured in public ceremonial surrounding the king. At Richard's coronation procession in July 1377, the Great Conduit in Cheapside was transformed into the Heavenly City, and a mechanical angel bowed down and offered him a golden crown.[14] An eyewitness account of Richard's reconciliation with the city of London in August 1392 records that "At his entry into Cheapside . . . came two angels down from a cloud, the one bearing a crown for the king . . . and the other another crown, which was presented to the queen. . . . [T]he conduits of the city . . . ran with wine . . . and angels made great melody and minstrelsy."

Elsewhere during the pageant, a throne was set up, surrounded by three circles of angels to symbolize the angelic orders attendant on God, while on the canopy of Richard II's tomb in Westminster Abbey, angels bear the arms of the king and of his first wife, Anne of Bohemia.

Angels were evidently part of the imagery used by Richard II to project his divinely ordained status. Westminster Hall, with its twenty-six angels bearing the king's arms on high, is the most monumental example of his attempts to assert absolute royal authority through art. But despite the heavenly images, Richard's earthly power was always precarious. His hauteur (he was the first king to insist on the title "Royal Majesty" and to require courtiers to bend the knee) and authoritarianism were not accompanied by political astuteness, and for most of his reign, power see-sawed between the king and a faction of nobles alienated by his absolutist style and unwarlike favourites.

Ironically, the first major event to take place under the newly constructed angel roof at Westminster was not a demonstration of Richard II's power, but the confirmation by Parliament of his deposition and replacement as king by Henry Bolingbroke, Henry IV, on 30 September 1399.

Why Are Most Angel Roofs in East Anglia?

If Richard II's preoccupation with the projection of royal power explains the first angel roof at Westminster, what is the reason for the subsequent concentration of angel roofs in East Anglian churches and their sparse occurrence elsewhere in England and Wales?

It has been suggested that the wide, bird-filled skies of the eastern counties inspired medieval East Anglians to adorn their church roofs with angels, as divine feathered intermediaries. This notion follows the art-historical theory of neuro-plasticity – the idea that the images and shapes that societies adopt in their art are subconsciously a product of environment and surrounding sensory influence.

Alternatively, Sandy Heslop, Professor of Visual Arts at the University of East Anglia, has argued that what is probably the first angel roof in the region (at St Nicholas, King's Lynn, likely to date from c. 1405-15) was built as a counterblast against the Lollard Heresy.

Lollardy was a kind of proto-Reformation movement of the 1400s, particularly strong in East Anglia. Its adherents rejected the authority of Church hierarchy, did not believe in transubstantiation and deplored the role of images in worship, viewing them as an idolatrous distraction. Crucially, the first Lollard martyr, William Sawtrey, was a priest at St Margaret in King's Lynn and at Tilney in Norfolk. He was burnt at the stake in London in 1401, and amongst the (many) charges against him was that he had said he would "rather worship a man . . . than an angel of God".

Professor Heslop has suggested that the construction of the angel roof at King's Lynn was a local repudiation of Sawtrey's statement and a reassertion of Roman Catholic orthodoxy through art, a fashion that then spread across East Anglia. (A similar anti-Lollard motivation has been advanced for the much later prevalence of Seven Sacrament fonts in East Anglia by Professor Ann Nichols in her book *Seeable Signs: The Iconography of the Seven Sacraments, 1350-1544*.)

However, many parts of the country have bird-filled skies, but not angel roofs, and the idea that the earliest East Anglian angel roof was motivated by a desire to repudiate one of the less prominent heresies voiced by William Sawtrey, at least four or five years after he had been executed in London, seems rather acrobatic.

Let us instead strip the problem back to first principles, and address some basic questions: What elements were essential to enable the widespread construction of angel roofs in East Anglia, or indeed, anywhere else? Furthermore, which of these elements was peculiar to, or disproportionately present in, East Anglia compared with other regions?

It seems to me that there are three preconditions for any ambitious construction project, medieval or modern: the money to pay for it, the will to do it and the technical expertise to execute it.

Money

Collectively, the three counties of East Anglia – Norfolk, Suffolk and Cambridgeshire – have the highest concentration of medieval churches in the world. There are over 650 in Norfolk alone.

Such density of church-building reflects the fact that in the fourteenth and fifteenth centuries, East Anglia was one of the most prosperous and highly populated regions in England. It had fine sheep pasture and good arable land, rich coastal waters and the geographic advantage of facing outwards across the North Sea to Europe and Scandinavia, and inwards, via a network of then more navigable waterways, to the domestic hinterland, making it a trading crossroads. Medieval East Anglia developed a strong regional identity, distinct and to a large extent economically independent from London, and a diversified economy, built upon wool, agriculture, fishery, manufacture and trade.

For much of the medieval period, Norwich was the second city of England, and ports such as King's Lynn (known in the Middle Ages as Bishop's Lynn) and Yarmouth were amongst the largest towns in the country.

East Anglia's sheepwalks produced fine wool and spawned a local cloth industry, centred on the towns of the Stour Valley, which was responsible by the fifteenth century for perhaps a quarter of English production. Finished fabric was sold both to the home market and into continental Europe; the great cloth market at Bury St Edmunds attracted merchants from London, Norwich, King's Lynn and Yarmouth and from as far afield as the Low Countries, Prussia and Italy.

Besides cloth, the eastern counties sold grain, ale, pottery and fish inwards and abroad, and also provided the English interior with a diversity of imported goods, both staples and luxuries, amongst them salt cod, sturgeon, wine, flax, dyestuffs, tar, bowstaves, Nordic timber, ashes, iron, furs and even hunting hawks.

East Anglian ports established reciprocal trading privileges with the members of the Hanseatic League, a mercantile confederation of northern European towns centred on Lübeck, Germany, but extending as far as modern Russia, Latvia and Poland. By the early fifteenth century, Hanseatic trading posts, or "kontors", had been established in Norwich, Boston and King's Lynn, and some Anglian merchants had themselves settled in Hanseatic towns to manage the overseas interests of their trading operations.

However, other parts of England were also rich in the 1400s, the wool-producing Cotswolds being a prime example. The Cotswolds too had its wealthy aristocrats and merchant parvenus. Elaborate and expensive churches were built there, as in East Anglia, but angel roofs were not a common feature in the rich wool counties of western England.

Will

Economic vitality brought with it social change. The profits of medieval East Anglian trade and manufacture – distinct from the returns of aristocratic land-owning – engendered a new "middle" class, well-off or outright wealthy, insecure because new-minted and sometimes uneasy at the corners cut and sharp deals made on the way up, but keen to display its success and social status.[15]

The parish church was a focal point for medieval communities, and so it became a canvas for the expression of economic and social attainment through rebuilding and beautification funded by the newly prosperous. Alongside the new "middle" class, established aristocratic elites continued to use their wealth to endow and improve churches.

It would, however, be wrong to ascribe the fifteenth-century boom in church-building – whether in East Anglia or other prosperous parts of England – *purely* to a desire to assert newly-won or long-held wealth and status. Wills, bequests and personal devotions demonstrate intense belief in the importance of charity, endowments and prayer as a way of reducing the donor's suffering in Purgatory, and in speeding the passage of the soul to heaven. Once again, however, such religious motivation was not peculiar to East Anglia.

Expertise

The high level of East Anglian expertise in carpentry and wood carving during the fifteenth and sixteenth centuries has been noted by several writers. At the level of small-scale carving, Arthur Gardner, in his 1958 book *Minor English Wood Sculpture, 1400-1550,* notes that finely carved church bench ends are found in large numbers only in East Anglia and the West Country.

East Anglia also excelled in large-scale constructional carpentry. This is clearly demonstrated by the distribution throughout England of single and double hammer beam roofs – the most complicated and audacious form of medieval timber roof.

In 1999, using the CD index to Pevsner's *The Buildings of England,* the Suffolk architect Birkin Haward found that of 188 surviving single hammer beam roofs in England, 65 per cent (124) are in East Anglia (defined here as Norfolk, Suffolk, Essex and Cambridgeshire). Suffolk has 55 and Norfolk 51, giving these two counties alone 56 per cent of the national total. For double hammer beam roofs, the pattern is even more extreme. *All* of the 32 surviving double hammer beam roofs in England are in East Anglia and Essex (21 in Suffolk, 4 in Norfolk, 4 in Essex and 3 in Cambridgeshire).[16]

Hammer beam roofs, with their many components, provide multiple surfaces for figurative carving, and so it is no accident that many of East Anglia's hammer beam roofs are also angel roofs.

Birkin Haward argued that the presence of large religious establishments in East Anglia, such as Norwich Cathedral, Thetford Priory and Bury Abbey, meant that there was a local pool of advanced expertise in carving and carpentry. This is probably true, as far as it goes, but many other parts of the country would have had comparable skill centres around major religious foundations, and, once again, those regions do not have a high incidence of hammer beam or angel roofs.

A New Solution

So how did the fashion and expertise for hammer beam and angel roofs come to be so heavily concentrated in East Anglia? I believe that the answer lies with the royal carpenter Hugh Herland, the creator at Westminster Hall of the first known angel roof and the first major hammer beam roof.

Westminster Hall's roof must have been substantially complete by 1398, because on 10 August of that year, Hugh Herland was appointed to a new project, the recruitment of labour for the construction of a new harbour in Great Yarmouth, Norfolk. The town was important economically as a centre of herring fishery, and strategically as a maritime base. By 1398, Herland was probably in his late sixties, and this was his last known major commission.[17]

The four men appointed to work alongside him in impressing labour were Hugh atte Fenn, Robert atte Fenn, John de Cleye and William Oxeneye. These men were East Anglians of substance and status, wealthy merchants involved in the governance of Yarmouth and, in the case of at least two of them, in the governance of the country as Members of Parliament. It was through such wealthy, influential locals – men with an economic and social stake in their communities – that royal policy was enacted in the provinces during the medieval period.

We know a lot about two of them.[18] Hugh atte Fenn (d. 1409) held the important office of Bailiff in Yarmouth nine times between 1383 and 1408, and represented the town at Parliaments in 1395, 1397 and 1399. A prominent merchant, trading in substantial cargos of fish, cloth, salt and grain, he owned two ships (one of them a fifty-tonner) and part-owned two other vessels in addition to a range of properties and lands in the area.

William Oxeneye (d. 1413) represented Yarmouth as MP in 1377, 1381, 1382 and 1397, and served as a bailiff in the town thirteen times. Also a wealthy merchant, he traded with Gascony, Prussia and the Low Countries in herring, wine, salt and cloth. Oxeneye owned at least two ships outright, and was part-owner (with Hugh atte Fenn and another) of a third ship, built at Cley next the Sea, Norfolk. In the 1370s he was engaged in royal maritime service, one of his merchant ships being recruited into the northern fleet. Like atte Fenn, Oxeneye had substantial property interests, and in 1392 he

gifted seventeen shops and £5 of rental income to the community to provide for the maintenance of Yarmouth's poor and infirm.

The Yarmouth harbour project is crucial. It provides direct evidence of Hugh Herland, fresh from building the first known angel and major hammer beam roof, working alongside rich, pious, status-conscious East Anglian merchants – exactly the class of people who would subsequently be responsible for commissioning many of East Anglia's angel roofs.

Such men travelled within the region, mixing and doing business with others of their class. Hugh atte Fenn, for example, had extensive property interests in Norwich, and used it as a centre for some of his trading activities, while William Oxeneye may well have been related to a namesake in King's Lynn who served there as a tax collector and chamberlain in the 1370s and 1380s. Tantalizingly, customs records for 1392-3 show this William Oxeneye of Lynn using a *Yarmouth* ship to carry his cargo, the only known instance of a Yarmouth vessel using King's Lynn's harbour in this period.[19]

Given the fame, scale and recency of Herland's work at Westminster Hall, it seems very likely that it was talked about during his interaction with the four East Anglian grandees who had been appointed beside him.

Like any builder, Herland would have taken trusted lieutenants to assist him on the Yarmouth project, and some of these men would surely have worked with him on Westminster Hall's roof. Herland was appointed to recruit labour, and so he and his team came into direct contact with East Anglian craftsmen, including carpenters, and perhaps also, given the region's maritime economy, shipwrights (a pool of craftsmen already expert in a different form of timber construction involving large components).[20]

I believe that this was the mechanism through which the idea of hammer beam and angel roofs was planted in East Anglia, along with the expertise required to build them and the initial appetite and fashion for them amongst the wealthy. No other region had this specific catalyst. No other region, as we have seen, has anything like as many angel or hammer beam roofs.

Some of the local craftsmen who worked with Herland at Yarmouth may have acquired enough knowledge or simply the inspiration to attempt hammer beam and angel roof construction themselves; members of his team from Westminster might even have stayed behind to undertake commissions in East Anglia once the work in Yarmouth was completed. Local gentry who came into contact with Herland or his team or heard talk of Westminster Hall's roof may have been inspired to commission such roofs themselves.

Once the expertise needed to build hammer beam and angel roofs had been planted in East Anglia, their spread throughout the region during the fifteenth century can be explained by local fashion and inter-community, inter-gentry rivalry.[21]

There is one more fascinating link. As we have seen, the earliest dateable angel roof in East Anglia is not (disappointingly) in Yarmouth. It is at St Nicholas, King's Lynn, and is generally thought to have been built between 1405 and 1410.[22] St Nicholas is a building of huge scale and magnificence, with one of the most breathtaking of all angel roofs. It would seem to have been funded by multiple donations from affluent King's Lynn merchants, rather than by a single wealthy donor. Medieval bench ends from St Nicholas, now in the Victoria and Albert Museum, London, carry detailed depictions of the merchant ships on which the town's prosperity was based.

One of the donors to the building of St Nicholas was a man called John Wace (d. 1399). Wace was, like Hugh atte Fenn and William Oxeneye in Yarmouth, a rich merchant, a Member of Parliament and part of his town's governing class. In his will of 1399, he bequeathed a total of £50, a very substantial sum at that time, towards the construction at St Nicholas.[23]

In 1398, John Wace was appointed to a commission to assemble ships against east coast piracy; so was William Oxeneye of Yarmouth, who, in the same year, as we have seen, also worked alongside Hugh Herland, impressing labour for the rebuilding of the harbour there. Can we trace a tentative line of transmission from Westminster Hall and Herland, via

William Oxeneye, to John Wace and his fellow King's Lynn merchants, who commissioned and funded the first angel roof in East Anglia?

This may be a step too far. But certainly we can show that in 1398, Herland came into contact with East Anglians from exactly the class that would subsequently go on to commission angel and hammer beam roofs, and that he also came into contact with a pool of East Anglian craftsmen, the class of men who would subsequently build them.

I am not aware that anyone has made this connection between Herland, the Yarmouth harbour project and the prevalence of angel and hammer beam roofs in East Anglia before, but it seems to me, at the very least, a plausible and tantalizing possibility.

How Were Angel Roofs Made?

No description of how angel roofs were constructed and raised survives; neither do any building inventories listing the pricing and components of an angel roof or hammer beam roof in a church.[24] Like the churches themselves, church records were a casualty of the Reformation and many were lost or destroyed.

By contrast, medieval royal building records are extensive, and amongst these is a fabric roll of 1395 for Hugh Herland's angel and hammer beam roof at Westminster Hall. It provides invaluable insight into how complex timber roofs, such as those in East Anglia, were built.[25]

The roof of Westminster Hall is fashioned from oak. Oak was the preferred wood for medieval construction, on account of its strength and durability. It is easily workable when recently felled, but over time dries and hardens to become exceptionally robust. Its failings are a tendency to warp and split as it dries (especially if the grain within the fashioned component does not run straight), and a particular vulnerability to attack by deathwatch beetle. Warping makes joints loosen and deform over the centuries, undermining structural stability, as can insect damage if it runs far enough. Both the effects of distortion and the marks of infestation can be clearly seen in many of the photographs in this book.

Though oak was the pre-eminent wood for construction in the Middle Ages, other varieties were also used, notably chestnut, which is softer to work than oak but ultimately similar in colour and toughness, and much more resistant to insect attack.[26]

The carved angels in the roof at Swaffham in Norfolk are made of chestnut (and show relatively few signs of insect damage), as are those at Necton in the same county. Necton's angels are painted, but those at Swaffham are now bare wood, and to my eye may have an oilier sheen than is found in medieval oak carvings.

A medieval roof carpenter needed literally to be able to see the wood *through* the trees. He could not simply purchase roof timbers of standardized sizes from a lumber merchant. Instead, he had to be able to identify trees *at source* – in woodland – which when felled and worked would yield components of the necessary size, shape and strength. An eye for live timber was amongst the many necessary skills of the roofwright.[27]

We know that the wood for Herland's roof at Westminster was sourced from at least three locations: royal and church forests in Hampshire, Surrey and Hertfordshire. The multiple sources reflect the unprecedented scale of the project, which required both a huge quantity of wood (the roof contains an estimated 660 tons of timber) and trees of great size from which to fashion the monumental components (the largest single pieces at Westminster – the hammer posts – are over 20 feet long and approximately 38.5 by 25 inches in section, weighing at least 3.5 tons each).[28]

Once chosen, the trees were felled and stripped of bark and branches. They were then squared up into beams before being sent to the carpenter's workshop or framing site, where the timber was laid out, marked, cut and fashioned into individual components. Medieval illustrations show carpenters working timber raised up on trestles, often outdoors (a necessity when working very large timbers). Hugh Herland's "frame" (the carpentry equivalent of a mason's yard) for the Westminster Hall roof was at Farnham in Surrey.

Medieval timber was often worked while still green, or relatively unseasoned; it was easier to

carve and cut in this state and would, at least initially, shrink more tightly into place when installed.

Although almost no medieval building plans survive in England, they were undoubtedly made.[29] Masons are known to have used "tracing floors" to draw out buildings, incising the design into a surface of soft gypsum from which templates and traced plans could then be taken. Two such medieval tracing floors survive in England, at York Minster and Wells. Medieval carpenters, who worked closely with masons, may well have used the same technique for making complex roof plans.

Craftsmen also kept sketchbooks in which they drafted out ideas or noted down structures for future reference, and master carpenters (and masons) made architectural scale models to plan and test complex structures.[30] In 1366, while working on an earlier project at Westminster, Hugh Herland was granted a house in the vicinity in which to make and store such models.[31]

Few medieval woodworking tools survive, but contemporary illustrations and texts such as the "Debate of the Carpenter's Tools", a humorous poem composed around 1500, give us a good idea of the range of implements used.[32] In the poem, a carpenter's tools take turns to explain how they help their master make money, and complain that he spends it on drink as fast as they can earn it for him. Twenty-eight tools are referred to, many of which – a chisel, an axe, an adze, a saw, a file, a plane, compasses, a crowbar and a gouge – are immediately familiar to a modern woodworker, while the names of others are more obscure. The list includes a "shype ax" (an axe with a crescent shaped blade, perhaps associated with shipwrights), a "belte" (a mallet), a "wymbyll" (probably a form of gimlet), a "groping iren" (perhaps a type of gouge), a "pryking knife" (a scribe used to mark wood), a "persore" (an awl) and a "skantylljon" (probably a carpenter's rule, "scantling" being a term for the dimension of timber).

Large timbers were cut into planks and beams using a two-man saw positioned over a saw pit, with most of the hard effort falling on the man down in the pit while the one above positioned and guided the blade. The sawing line on long timbers was marked using a cord coated with chalk, stretched taut and snapped back to leave a chalk line on the wood.

The axe, in various forms and sizes, was an important tool in carpentry, used for both rough shaping and smooth finishing. For fine smoothing, medieval carpenters seem to have used the abrasive skin of the dogfish; "houndfish skin" is recorded amongst carpenters' supplies at Westminster in 1355.

To join timber components together, carpenters used three main joint types, which occur in endless variations and combinations. The finest are works of great precision, ingenuity and beauty in themselves. As William Bryant Logan observed, "It is hard for an ordinary carpenter even to conceive the patience, persistence and delicacy with which the great joints were made."[33] Excellent drawings of actual medieval joints can be found in the appendices to Cecil A. Hewett's *English Historic Carpentry* (1997).

Timbers were most commonly connected with *mortice and tenon joints* (where a projecting tab, the tenon, on one component fits into a corresponding slot, the mortice, on another). Stepped or staggered *scarf joints* were used to connect pieces of wood together to gain the required length. *Lap joints* interlocked timbers that crossed one another. Finally, the *dovetail joint* was used particularly to fix horizontal tie beams into wall plates, where the tie beam was subject to outwards pull from the walls. All of these joints were cut by hand, using the tools described above, and secured only with wooden pegs, termed "tree nails". Metal nails were not used in medieval structural carpentry, except to fix the external roofing boards to the rafters.

For a roof as large and complex as the one at Westminster Hall, there were thousands of components to be fashioned and thousands of joints to be cut – all by hand. Herland's team would have been very sizeable. The king had pre-emption rights over labour and could divert craftsmen from others' jobs as he saw fit; royalty did not like to be kept waiting.[34] Nonetheless, it still took almost two years to make the Westminster roof components at the frame in

Farnham. Once fashioned, the thousands of pieces would have been test assembled on the ground, marked to show how they fitted together and then dismantled.

By mid-1395, Herland's colossal roof was ready to move. On 1 June, the order was given to send thirty strong wagons – each drawn by a team of up to sixteen horses – to carry the roof parts from the framing site in Farnham to Ham on the Thames. Each cart took five loads in the month following Trinity Sunday on 6 June. From Ham, the loads were transferred to barges for the final journey to Westminster by water.

Transportation was a significant element of total building expense in the Middle Ages. Where available, water was always preferable to road for the freighting of heavy loads.[35] Medieval roads, especially in rural areas, were generally unsurfaced, and often poorly maintained. East Anglian angel roofs would often have travelled significant distances from the carpenter's framing site to their final locations. It has been suggested that the magnificent angel roof at Knapton, in north Norfolk, was manufactured in a Suffolk workshop and brought in by water.[36] Similarly, the massed angel roof in March, Cambridgeshire, may well have been made in or near Bacton in north west Suffolk, over fifty miles away.[37] If so, water would have been used for as much of the journey as possible.

Raising the components of an angel roof into place was hard and dangerous work. Multi-component sections of the roof ("trusses") were assembled at ground level and then lifted up to the top of the church walls to be jointed securely into the wall plates (horizontal timbers that ran along the top of the walls and were themselves let into the masonry; carpenters would have worked in close co-operation with masons). Roof carpenters worked from scaffolding made of wooden poles topped with a platform of wicker hurdles or boards. Scaffolding was lashed to the walls or set on horizontal beams slotted into purpose-cut holes in the masonry (these "putlog" holes can still be seen in many medieval buildings). Where a roof had tie beams, these would be installed first and then used to support sturdy working platforms. As

the roof progressed, the scaffolding was moved up to the next level. Roof parts were lifted from the ground using treadmills, hand-rung-operated winches and framed pulley systems.[38]

Angel Roof Patterns in East Anglia

The vast majority of angel roofs in East Anglian churches are pitched (sloping). Pitched roofs allow rain and snow to run off, and, of course, provide added height within the church, drawing the eye upwards to a "heavenly" plane populated by angels. (See Appendix 2 for diagrams of the most common East Anglian roof types.)

But sloped roofs impose particular stresses on the building below. Their weight, transmitted down the rafters, exerts outwards thrust on the walls, an effect that is exacerbated by wind forces on the outer surface of the roof. Medieval roofwrights evolved designs to counter and dissipate these strains.

Tie Beam Angel Roofs

Horizontal *tie beams* (which are usually the longest and thickest pieces of timber in the roof) were jointed into the wall plates to tie the walls together (in this function, they are under *tension*, or pulling force), and to siphon wind pressure on one side of the church over to the opposite wall (in this function, they are in *compression*, experiencing pressing force). The tie beams were often given additional support by jointing curved *arch braces* into their underside, and the arch braces themselves were frequently connected to long timber posts (*wall posts*) that ran down the interior of the wall, resting on a projecting stone bracket (known as a *corbel*). The wall posts carry the roof's thrust down to a lower level, reducing outwards leverage, and help to pin the roof structure into the walls. The wall posts themselves do not actually bear much weight; the corbels on which they rest are often only set into the walls by a few inches.

The angle created by the intersection of a curved arch brace and a horizontal beam is called a *spandrel* and lends itself to decoration. In East Anglian roofs, spandrels are often filled

with elegantly fretted tracery (for example, at Banningham in Norfolk, elegantly fretworked angels swing censers in the spandrels nearest to the altar).

Tie beams themselves provide limited opportunity for sizeable angel carvings, and so when they are used in angel roofs, they are usually alternated with another pattern – typically short, projecting plates, which are effectively cosmetic hammer beams – which can carry full- or half-length angels. The alternating tie beam/hammer beam roof form occurs throughout East Anglia. There are good examples of the design type in Norfolk at King's Lynn, Hockwold, Emneth and Methwold; in Suffolk at Mildenhall, Lakenheath, Badwell Ash and Ufford; and in Cambridgeshire at Landbeach and Soham.

Arch-Braced Angel Roofs

Though very effective at countering outwards thrust, tie beam roofs had their disadvantages. The big horizontal beams interrupted the roof space, detracting from the sense of height, and they were costly, since they required very large trees from which the tie beams could be fashioned as a single piece. An alternative was to use paired *arch braces*, which curved gently upwards from the wall posts to meet at the roof apex and were tied together with high-level *collar beams*. The arch braces could be made in sections from several shorter pieces of timber, jointed together, and, because the collar connected the two sides of the arch high up where the gap between them was narrower, the collar itself could be made with timber of shorter span. This design type leaves most of the roof space open, but is less effective at containing outwards thrust, and can put the collar itself under major strain. In arch-braced angel roofs, the carpenter often uses hammer beams on every other arch (as for example at St Mary's, Bury St Edmunds, and Hawstead in Suffolk) to lay off some of the stresses and provide a platform for angel sculptures. The same pattern occurs in Norfolk (e.g. at All Saints, Necton), but in that county, the collar beams are generally omitted; collars would seem to have been very much a Suffolk design trait.[39]

Cambered or Firred Angel Roofs

An alternative to the pitched roof is the gently sloping *cambered* or *firred* roof, which has just enough incline to allow water to run off. Such roofs exert very little outwards thrust, since they sit on the wall tops like an almost flat lid. This design type, in which the roof is supported by a series of tie beams that have a slight upwards curve or camber – like a very wide, shallow-peaked, inverted V – is comparatively rare in Norfolk and Suffolk. If the beam is a single piece of timber with a gentle upwards slope, the roof is termed *cambered*. Where the beam itself is square, but has had a separate sloped piece added on top, it is called a *firred* roof.

The finest and most famous example of this type in the region is the angel roof at Holy Trinity, Blythburgh, close to the Suffolk coast. Eleven pairs of angels face outwards from the mid-point of the tie beams along the ridge of the roof; they carry shields blazoned with the arms of the roof's principal sponsors. Remarkably, both the angels and the roof beams at Blythburgh still retain much of their original colouring; this, combined with the abundance of light within the church, makes it one of the most breathtakingly beautiful of all angel roofs.

Cambered angel roofs are more common in Cambridgeshire. For example, at Ellington and Great Gransden, cambered tie beams alternate with carved angels projecting from the wall plates.

Hammer Beam Angel Roofs

The hammer beam is the most complex and elegant medieval timber roof form. It is also, as has already been noted, overwhelmingly an East Anglian phenomenon, occurring in two main types.[40] In a *single hammer beam roof*, a horizontal beam (the hammer beam) projects from the wall plate, and is generally supported from below by a curved brace that connects into a *wall post*, the end of which sits on a bracket or *corbel* set into the wall. A vertical *hammer post* projects upwards from the end of the horizontal hammer beam and is jointed into the sloping roof rafter to create a strong right-angled triangle (see Appendix 2 for diagrams).

In single hammer beam roofs, the hammer beam itself may be carved into a full-length,

horizontal angel (see, for example, Holme Hale, Norfolk, and Southwold, Suffolk), or a smaller angel carving may be set on the end of the hammer (as at Banningham and Trunch in Norfolk). At Cawston in Norfolk, angels over 6 feet tall, clad in suits of feathers, stand *upright* (uniquely) on the hammer beams. Cawston's angels still have much of their original paint.

A *double hammer beam roof* stacks one hammer beam truss on top of another. In these roofs, a second hammer beam (supported by a curved brace) projects from the top end of the hammer post below it. If the upper hammer beam has a hammer post connecting it into the rafter, the roof is a *true* double hammer beam ("true" because the upper hammer beam, like the one on the lower tier, is actually bearing load). Where the upper hammer beam has no hammer post fixing it into the rafter, it is a *false* double hammer beam ("false" since the upper hammer beam is purely decorative, and carries no load).

A further variant is the *pendant* double hammer beam roof, in which the vertical hammer posts extend below the end of the horizontal hammer beam, terminating in an elaborately carved finial (as at Earl Stonham, Tostock, Wetherden and Cotton in Suffolk).

The many beam ends in double hammer beam roofs lend themselves to massed angel decoration. Typically, angels carved in low relief are set on the hammer ends, their wings outstretched, creating the impression that the whole roof is being borne aloft. Spectacular examples can be seen at March in Cambridgeshire, Cotton and Woolpit in Suffolk, and at Gissing, Swaffham and Knapton in Norfolk. The latter has almost 140 carved angels perched on the hammer beams.

The simple categorizations above may give the impression that angel roofs fall neatly into clear-cut design types. While some do, many combine elements from the different design types.

When Were Angel Roofs Built?

When were angel roofs built? We can answer the general question with a high degree of confidence. A start date for the genre of c. 1395 is provided by the first known angel roof: Hugh Herland's roof at Westminster Hall. An approximate end date is provided by Henry VIII's break with Rome in 1534, which marks the start of the Reformation, and of official hostility towards and destruction of religious images. As we know, the earliest dateable angel roof after Westminster Hall is that at St Nicholas, King's Lynn (usually dated to 1405-10). The fact that it is the earliest we *can* date does not of course mean that it was necessarily the first to be erected in the region.

The break with Rome in 1534 is an *approximate* rather than an *absolute* end date for angel roof building since the rate at which the new religious orthodoxy took hold varied across the country. At Llanidloes in Wales, the angel roof dates from 1542, making it the latest angel roof of which I am aware. This roof was either a very daring act of defiance against the new religious norms, or, more probably, Protestant orthodoxy had not yet established its grip in mid-Wales. The era of medieval angel roof building thus spans a period of roughly 140 years.

Assigning dates to specific angel roofs within this approximate 140-year range is much more difficult, since "For the vast majority of parish churches, there are no medieval fabric rolls or building accounts, and no recorded dates that can be linked to the structure or to the fittings."[41]

Very, very rarely, the fabric of the roof carries a date. Thus, for example, at Bardwell in Suffolk, one of the four surviving roof angels carries a book with the date 1421, which also allows us to identify the probable donor as Sir William de Bardwell, lord of the manor of Bardwell at the time. Sir William was a noted benefactor to the church and served as standard bearer to Henry V during the wars in France. A donor portrait in a window on the north side of the building shows him kneeling in prayer, clad in full armour (see p. xiv) – perhaps the very same gilt armour he left to his son in his will.[42]

Occasionally, bequests in medieval wills can help to date an angel roof. Thus, for example, a 1419 will donation to St Nicholas, King's Lynn, referring to the church as "*de novo aedificato*" ("newly built"), forms part of the basis for dating the angel roof there to early in the fifteenth

century.[43] An eye witness account of a window at St Nicholas bearing the date 1413 – now vanished – pushes the date back further to c. 1405-10.

For most of East Anglia's angel roofs, however, there is no available evidence to help us assign a precise date of construction. Roof style may perhaps give some guide, but it should not be overplayed. Birkin Haward believed that roofs where the hammer beams are carved into full-sized recumbent angels pre-date those where the angels are rendered as low relief plaques on the beam ends, but there is no real proof of this. It *is* reasonable to assume that the double hammer beam roof type emerged after the single hammer beam, since it is an elaboration of the latter, but that does not mean that all double hammer beams are later than all single hammer beams; the two forms overlapped and co-existed. Similarly, a more complex or accomplished roof cannot be taken as later than a simpler or more crudely executed one; much would have depended on the budget available and the skill of the craftsmen employed.

Dendrochronology – tree ring dating – would enable us to establish the exact year in which the timber for a roof was felled and hence, since medieval timber was worked while green or at least relatively unseasoned, to establish quite precise dates for the construction of East Anglia's many angel roofs. However, a comprehensive dendrochronological survey would be extremely expensive and time-consuming and no one has so far undertaken it.

Where there is dating evidence for the roofs featured in the photographic section of this book, I have cited it in the captions.

Who Made East Anglia's Angel Roofs?

The names of many carpenters active in East Anglia during the era of angel roof building have survived. Haward assembled the names of eighty carvers and carpenters who worked wholly or partly in Suffolk in the late Middle Ages and observed that the list "must include many of the craftsmen whose remarkable skills

can be seen in . . . church buildings of the area", but the evidence is lacking to show which, if any of them, actually built angel roofs, and there is less still to link any of these individuals to specific angel roofs.[44] The one exception of which I am aware is the angel roof at St Benet, Cambridge, where a contract from 1452 survives naming the carpenter as "Nicholas Toftys of Reche in the shire of Cambrigg"; however, little of the original roof remains after an extensive Victorian restoration of the church.[45]

Given the number and complexity of angel roofs, especially the hammer beam roofs, it is clear that some carpenters' workshops were specializing in the genre. Marked design similarities between roofs in different parts of East Anglia suggest that in these cases, the same workshop or craftsmen may have been responsible. Based on the existence of a cluster of false hammer beam roofs of similar type in the area around Bacton in Suffolk, Haward argued that there was a major workshop centred on or near the village. The roof of St Wendreda in March, Cambridgeshire, is of similar design and may have come from the same workshop or workshops, but we cannot match the name of any known carpenter to the roof.[46]

We know that skilled carpenters travelled within (and outside) East Anglia to work on construction projects. The Rollesby brothers of Bacton, in Suffolk, worked on the Guildhall in King's Lynn, Norfolk, in 1421, and at Clare Castle in Suffolk in 1451, while John Goneld from Bury St Edmunds was engaged as carpenter at Christ Church, Canterbury in 1437, and in 1445 was master carpenter for the repairs to the bridge at Rochester in Kent. Then, as now, carpenters went where the work was.

The best of them made a good living. Many medieval carpenters' wills survive; one had to be reasonably well off to make it worth leaving a will at all. Amongst these is the testament of William Cotyngham of York, who died in 1457 and left bequests including £1 to York Minster, legacies of various robes, a candlestick, a dagger decorated with a silver rose, and a best silver spoon, all indicating a comfortable lifestyle. The

will of a John Goneld of Bury (who is probably the carpenter mentioned above) from 1445 refers to his tenements and land in the town.[47]

At the highest levels, master carpenters such as Hugh Herland enjoyed lavish rewards and eminent social status, dining with their wealthy patrons and receiving pensions for life and grants of property.[48]

At the more mundane end of the spectrum, summer day rates set for master carpenters in a statute of 1446 were 4d with food or 5½d without (implying a man could feed himself for a day on 1½d), and 3d or 4½d in winter (reflecting the shorter daylight and working hours). In the same document, simple labourers are to receive 2d a day with food or 3d a day without in summer and 1½ or 3d in winter.[49]

The men who were contracted to build East Anglia's elaborate angel roofs sit between the two ends of the spectrum, and somewhat closer to the upper end than to the mid-point; working for roof sponsors who were generally local grandees or nobles, most were masters of design and construction, running a workshop, managing a team of carpenters and charging a fee for projects that covered their costs and gave them a margin.

In addition to carpenters operating in the open market, there were pools of craftsmen attached to the region's large religious establishments – men such as Richard Aleyn, whose will of 1468 suggests that he was a salaried craftsman in the sacrist's office at Bury Abbey, and John Derman (d. 1497), who was probably master carpenter at the Abbey, and who by the time he wrote his will had done well enough to accumulate a portfolio of properties in the town.[50]

Who Carved the Angels?

Medieval carving was closely linked to architecture and may initially have developed out of stonemasonry. The first reference to an "imager" – a specialist figure sculptor – occurs in London in 1226 when one Thomas the Imager is named in a London rape case; and in a document from the 1290s, Alexander of Abingdon, who supplied statuary for the Eleanor cross at Waltham Cross, is described as an "imaginator",

a carver of images. Given the demand for wooden devotional images, crucifixes and roods in churches, carvers specializing in wooden figures were long established by then.[51] By the late fourteenth century, when English began to replace Latin and French in official documents, the term "carver" was in use.

There is great variation in the style and quality of the carving in East Anglian angel roofs. The finest are masterpieces. The angels at Methwold, in Norfolk, or in the roof at St Mary, Bury St Edmunds, which was made around 1445 for the wealthy clothier John Baret, fall into this group. Such sculptures are the works of absolute masters and deserve comparison with the best medieval carvings in any museum in the world, but because they are distant, inaccessible and fixed, they remain little known. The Bury roof angels are probably the work of carvers attached to Bury Abbey; Baret's will reveals that he was a confidant of the abbot and includes bequests to the abbot and other clergy there.

At the opposite end of the scale are figures – such as those at Hockwold, Norfolk – of a much cruder and more rustic quality. Though they are not without charm, one hopes that the man who made Hockwold's angels was not solely reliant on his carving for a living. The roof itself is a fine arch-braced tie beam structure. It may be that the angels are the work of a man who was primarily a carpenter. In most roofs in East Anglia, the angels are good enough to suggest that they were the work of specialist carvers. (Photographs of the carvings at Methwold and Bury are included in the photographic section of the book.)

From wills and contracts, we have the names of many carvers and carpenter-carvers who were active in East Anglia during the era of angel roof building, but the evidence is lacking to definitively link any of these names to specific angel roofs.[52]

But though it is not possible to put carvers' names to individual angel carvings, having now photographed over 120 angel roofs, I find that it *is* possible to trace the same hand at work in different locations. The angels in the roof at St

Nicholas in King's Lynn are the work of at least three different carvers, each with their own way of rendering faces, eyes and drapery. One of them is a man who carves hair in crisp, springy ringlets; his angels have almond-shaped eyes, without incised pupils; and he renders cheeks with such softness and delicacy that were you able to touch them, you feel the oak would dimple under your finger. The angels at Methwold, Norfolk, some 30 miles away, were clearly carved by the same man. Since we cannot know his real name, I have christened this outstanding sculptor the "Methwold Master".

Another angel carver whose work is found at St Nicholas, King's Lynn, renders hair in deep, undulating hanks, rather like intestines; he carves eyes with heavily incised "bull's eye" pupils, and gives his figures high-necked "mandarin collars". The same style traits are found in roof angels at Mildenhall, Suffolk. There are also strong similarities between the King's Lynn and Mildenhall angels and those at Upwell, Norfolk.

Style links can be traced in the secondary carvings on angel roofs too. Thus, for example, the elaborate roof bosses set into the ridge at Wymondham Abbey, Norfolk, and those on the roof at Haughley, Suffolk, are so similar in design that they are probably the product of the same carver, or at least the same workshop.

There is much more work to be done in the field of carver attribution in angel roofs; where an identifiable hand appears in a roof for which we have dating evidence, it may then help us towards dating other roofs containing the same carver's work, though an obvious limitation is that we cannot tell whether a particular piece of work dates from early or late in a craftsman's career.

It is by no means certain that all the carvers of angel roofs in East Anglia came from the region. Medieval carvers travelled widely. This was probably a necessity in such a specialized trade. Even in England's largest city, London, local demand for images sufficient to sustain a sculptor was not guaranteed. The London carver John Massingham provided "ymagerie" for a building in Canterbury in 1436; in 1438 he worked at All Souls, Oxford, for fifteen weeks; and in 1448 he

received £10 for making an image of the Virgin for the high altar at Eton College in Berkshire.

Medieval East Anglia's church-building boom also drew in craftsmen from overseas. A Robert Mundeford is recorded in 1455 as a carver and an alien. He would seem to have been related to the Dutchman William Mundeford, who came from Utrecht and worked in a prominent glazing workshop in Norwich from the mid-1430s. An earlier Dutch carver was employed at Norwich Cathedral in 1415, and two more carvers active in Norwich in the mid-fifteenth century, Thomas Alman and Robert Hakun, have names that suggest they may have come from Germany and Norway respectively.[53]

Skilled carvers were paid well. Building accounts from 1395 for the roof at Westminster Hall detail the payments made to the men who carved the hammer beam angels there. Robert Brusyngdon received 26s 8d apiece for carving four angels. Subsequent carvers received 15s per angel, as did Brusyngdon for making a further two angels. The angels at Westminster are all very similar in size and design; it would seem that the high price Brusyngdon got for the first four was because he was establishing a design template for other carvers to follow.

15s per angel is nonetheless equivalent to about thirty days' pay for an "ordinary" master carpenter.[54] Admittedly, the Westminster carvings are very large and intricately detailed (each angel carries a shield on which the royal arms are minutely rendered), but as we have seen, the carver Robert Massingham received £10 for carving a single statue of the Virgin Mary at Eton in the 1440s. Richard Aleyn, a salaried carver attached to the Abbey at Bury St Edmunds, was well-off enough when he died in the 1460s to leave a bequest of 40s to the Monastery of St Edmund and legacies to other churches in the area.[55]

Master carvers, as professional craftsmen, enjoyed a measure of social respect, and some even attained high local office. William Brownfleet, head of a successful carving workshop, became mayor of Ripon in 1511, while his fellow carver Thomas Drawsword was mayor of York in 1515 and 1523.[56]

Colour

Medieval devotional and commemorative statues were usually painted, and sometimes part-gilded. Painters' materials included red ochre, oil, wax, verdigris (for making greens), red and white lead, sinoper (a rare earth used in red paints) and gold leaf. The best pigments were expensive and often had to be imported; materials were so valuable that at Westminster in 1541 the paint-making workshop was kept under lock and key. Medieval accounts often show that the bill for painting a statue was higher than that for carving it; this probably reflects the cost of gilt and pigments.[57]

While it is tempting to suggest that roof angel carvings were brightly coloured to make them stand out high up in a space lit only by windows and candlelight, it is not clear that this was always – or even predominantly – the case. Roof angels were not devotional statues nor the object of individual focus, but were part of the overall roof scheme. I have taken thousands of close-up photographs of angel roof carvings (most from ground level, but using powerful lenses), and many of these, even when further magnified, reveal no *discernible* trace of colour. In such cases, there are three possibilities:

 i. The angels were originally painted, but over time the paint has fallen off with an extraordinary uniformity.

 ii. The angels were originally painted, but at some point the paint was removed with incredible thoroughness. If so, it is not clear who would have had the motivation to undertake so onerous and painstaking a task. Iconoclasts would have found it easier either to remove or mutilate the angels, as discussed later in this book.

 iii. There is no discernible trace of paint because the angels were never actually painted. This is clearly the most economical argument.

Without undertaking a systematic surface analysis to search for traces of medieval paint, the best one can confidently say is that at some locations, some or occasionally all of the angels were picked out in colour, while elsewhere, they were apparently left unpainted. Where paint was used, the most commonly decorated sections were the bays nearest the altar, which formed the "ceilure" or "canopy of honour" in front of the rood beam with its sculpture of the Crucifixion.

Thus, for example, in the roof at St Nicholas, King's Lynn, electron microscope analysis undertaken in 2004 detected pre-1700 – probably medieval – paint on the sub-surface of the large angels in this section of the roof, but concluded that paint on the wall plates and demi-angels there was added later. When I examined the roof at eye level in 2014-2015, I saw no discernible traces of paint on any of the other large medieval angels in the nave roof.

Similarly, an eye level inspection of one of the angels in the nave at Wymondham Abbey in 2015 revealed no obvious signs that it had ever been painted, though the angels in the ceilure there bear what appears to be medieval colour. Given the cost of pigments in the middle ages, budget rather than aesthetics may often have determined to what extent colour was applied to a roof.[58]

Roofs that retain much – apparently original – colour can be seen at Salle and Cawston in Norfolk, and at Blythburgh in Suffolk. At Palgrave in Suffolk, iconoclasts stripped the angels from the ends of the hammers, but the roof timbers are still beautifully patterned in red, green, white and black. The roof at Ufford in Suffolk also retains apparently original colours, though the angels themselves are replacements, carved in 1890.

Some roofs have been repainted by modern or Victorian restorers, presumably reflecting an original medieval paint scheme; amongst these are Bardwell; Bacton (where the angels themselves were removed in the 1640s); the two angels nearest the altar at St Mary, Bury St Edmunds, in Suffolk; and Necton, Banningham and South Creake in Norfolk. The gilded and painted angels in the chancel at Southwold, Suffolk, are entirely Victorian, dating from 1867. The paint on the figures in the massed angel roof at Knapton in north Norfolk appears, at least in parts, to be modern.

One re-imagining of a polychromed medieval angel roof deserves mention. At St Mary in Huntingfield, Suffolk, the rector's wife, Mildred Keyworth Holland, personally decorated the entire church roof between 1859 and 1866 with painted angel panels and roof angel carvings, commissioned from local craftsmen. The roof, which is an entirely Victorian creation, blazes with colour. It is an extraordinary and rather overwrought conception of a fully painted medieval angel roof.[59]

Angel Depiction and Iconography

It seems likely that the depiction of angels in church art, including angel roofs, was influenced by the costuming conventions of medieval liturgical dramas and mystery plays. Drama played an important part in religious instruction for a largely illiterate laity; it is logical that carvers depicting angels would copy details that they had seen in theatrical depictions, which were familiar to all.[60]

Roof angels are often shown clad in suits of feathers, terminating at the neck and ankles (as at Cawston in Norfolk, on the archangel figures in the roof at St Mary, Bury St Edmunds, and on some of the carvings at Kimbolton, Cambridgeshire). We know that the actors portraying angels in pageants and mystery plays wore similar suits, with the feathers rendered by tabs of cloth or leather sewn on to the fabric.

When roof angels carry the crown of thorns, an emblem of Christ's Passion, this is often carved not as entwined branches, but as a thick, apparently padded torque, set with individual spikes (e.g. at Methwold and Upwell in Norfolk, and Kimbolton in Cambridgeshire). I think it is very likely that this reflects the way the crown of thorns was depicted in medieval theatrical costuming.

Roof angels are often shown as half-body figures, from the waist up, and these demi-angels usually issue from undulating, fabric-like folds. Those playing angels in mystery plays often stood in raised "pulpits" – putting them on a higher, heavenly level – which obscured the lower half of their bodies and were edged with similar folds of fabric or fluffy wool, emulating clouds.

Distinct types of iconography are employed in angel roofs. One of the most common conventions is to show the angels bearing the instruments of Christ's Passion: the scourge, the spear and sponge, the ladder, the hammer and nails, the dice and torn robe of the Crucifixion and so on.[61]

Another convention is to depict the angels as a heavenly orchestra, playing a variety of musical instruments (e.g. St Nicholas, King's Lynn) or as co-celebrants in the Mass (as at St Mary, Bury St Edmunds), their hands raised as if in prayer or conducting the choir below.

Such depictions derived context and resonance from the presence of the (now vanished) rood in the chancel arch, with its central sculpture of Christ crucified. The rood and the roof angels above it interacted. They occupied an upper airspace in the church. The angels hovered in attendance on and adoration of Christ's sacrifice. They drew the eyes of the worshipper to contemplation of the heavenly realm above, while the Doom painting, which often backed the rood, provided a graphic reminder that entry to heaven depended on one's actions in the world below.

Roof angels are sometimes shown bearing the emblems of saints, as, for example, in the exquisite double hammer beam roof at Gissing in Norfolk; it conjures up the "holy company of heaven", the communion of angels and saints that featured in the liturgy and was so often invoked in wills. More mundanely, angels sometimes simply carry the heraldic arms of the principal sponsors of the roof, as at Blythburgh, Suffolk.

The Presence of Angels in Medieval Life

Angels – or at least human depictions of angels – made regular appearances in medieval life, and these were not confined just to mystery plays or liturgical dramas. The accounts of a pageant held at London Bridge in 1464 to celebrate the coronation of Elizabeth Woodville include a record of 21d spent on 900 peacock feathers for making angels' wings for enactors.[62] The celebrations held in the city of London in November

1415 for Henry V's victory at Agincourt featured heavenly choirs of angels, played by little boys clad in white robes with wings and gold-painted faces, while at Cornhill more boys dressed as angels and archangels showered the king with gold coins and laurel leaves.[63] As noted earlier, a mechanical angel offered Richard II a golden crown during his coronation procession in 1377, and figures dressed as angels appeared in the celebrations marking his reconciliation with the city of London in 1392.

Mechanical angel figures also featured in the processions of religious or trade guilds. Council minutes for King's Lynn from 1442 refer to the expense of maintaining the "springing" angels used in the Corpus Christi procession. Moving angel figures were also used in churches. At Norwich Cathedral in 1401, an angel was installed in the roof that swung down during the Mass to cense the congregation. St Margaret, King's Lynn, had a set of angels that descended from the roof at the elevation of the Host and retracted at the end of the Mass.[64]

To the medieval mind, angels and demons were not mere metaphorical abstractions, but vivid, real and present in daily life. The world had begun with Genesis, and was progressing inevitably to the Apocalypse; in between, good and evil contested ceaselessly.

This earth was a microcosm of an ordered universe, with God at its centre; and acceptance of a complete and divinely inspired organisation implied recognition of the reality of evil and the omnipresence of its ministers. . . . [D]evil-dodging was an everyday occupation of the Middle Ages, in which the aid of the Virgin and saints . . . was continually invoked.[65]

Angelic support was called upon in medieval prayers, and the concept of a personal guiding angel – a "good" or "familiar" angel assigned to the soul at birth – was well established.[66] It seems that in England, there was a particularly strong and longstanding tradition of devotion to angels. The Anglo-Saxon theologian Alcuin wrote of the angels as intercessors, while Herbert of Losinga, Bishop of Norwich in the eleventh

century, specially praised them.[67] Several English prayers to angels survive from the fourteenth and fifteenth centuries, amongst them this from an illuminated prayer book in the Harleian collection of the British Library (Harley 2445):

O Gloriouse angell, to whom our blessyd lord of his most mercyfull grace hath taken me to kepe: to thee, I, synful creature, crye and calle, with hertely mynde, besechyng the[e] ever to be singuler comfort to me in all my nede. Suffer me never to be over come with tentacyon or synful dede, but helpe me, that by grace I may ever in virtuous livynge procede. At the hour of my deth be present, that my gostly enemy in me have noo power. And after bryng me to the blysse, where ever with the[e] I may lyve and prayse our Saviour. Amen.

Protecting angels appear in manuscript illustrations, such as the fourteenth century *Savoy Hours*, in which they shield a knight in battle, or the *Hours of Francesco Sforza*, in which a towering guardian angel is shown leading his diminutive charge by the hand.[68] Medieval theologians devoted much thought to the nature of angels, and evolved complex angelic hierarchies which categorized angels by their type, form and role in the ordering of the universe. Medieval angelology was much influenced by the *Celestial Hierarchy* of Pseudo-Dionysus, a work written around AD 500 which became popular in western theological schools from the twelfth century onwards, informing writers such as Aquinas, Bonaventure and Julian of Norwich. The *Celestial Hierarchy* sets out nine orders of angels, grouped in three "choirs", arranged in descending seniority. The first choir, and that closest to God, comprises Seraphim (with six wings), Cherubim (their wings covered in eyes) and Thrones (wheel-like in form); the second is made up of Dominations, Virtues and Powers; and the third and lowest choir consists of Principalities (with two sets of wings), Archangels and Angels. These categorizations sometimes feature in medieval art; the West Front of Wells Cathedral carries sculptures of the nine orders of angels, and they also appear on painted altar screens such as that at St Michael,

Barton Turf, in Norfolk. However, angel roof sculptures are generally confined to the two lowest orders, those closest to and most involved with mankind: the angels and archangels. These figures are shown with a single pair of wings, as in the angel roof at St Mary, Bury St Edmunds, where all the sculptures are angels, save for two archangels towards the west end of the church, denoted by their sceptres and diadems.

The Destruction of Angels

The image destruction of the Reformation can be split into two distinct periods. The first runs from roughly 1535-1570, encompassing the latter years of Henry VIII, the reign of his successor Edward VI and the early years of Elizabeth I. Though the volume of destruction in this period was huge, it focused primarily on devotional images that had become objects of veneration in their own right, and upon manifestations of the Roman Catholic doctrine of the communion of the living and the dead. In the words of John Morrill:

> The first Reformation [of 1535-1570] was principally directed against the doctrine of the communion of saints, the doctrine that bound together the living and the dead as a community of believers helping one another in preparation for the day of judgement. The living prayed constantly for those members of their family . . . who had gone before them. . . . They looked to the saints and the host of heaven to watch over and protect the living and to intercede for them with the Father. Every active manifestation of that communion of the living and the dead was destroyed in the first generation of the Reformation: the side altars, the chantries, the reliquaries, the shrines, the Doom, and the paintings that illuminated that theme. . . . Most of the images in stone and wood which . . . survived were ornamental (bench-ends, roof adornments) rather than instructional.[69]

Given this focus, it is unlikely that angel roofs, whose images were decorative rather than devotional, were greatly targeted in this first

wave of iconoclasm, though some may have suffered at the hands of zealots.

Most damage to angel roofs instead occurred in the second phase of image destruction, the Puritan iconoclasm of the 1640s, at the time of the English Civil War. This renewed destruction sprang from a belief amongst radical Protestants that true Reformation was obstructed by the continued presence of images that diverted attention from the word of God and resonated with discredited Roman Catholic theology. As a result, Parliament passed injunctions in 1643 and 1644 for "The demolishing of Monuments of Idolatry and Superstition", requiring that such images be stripped from all churches and chapels:

> The Lords and Commons assembled in Parliament, the better to accomplish the blessed Reformation so happily begun, and to remove all offences and things illegal in the worship of God, do Ordain, That all Representations of any of the Persons of the Trinity, or of any Angel or Saint, in or about any Cathedral, Collegiate or Parish Church, or Chappel, or in any open place within this Kingdome, shall be taken away, defaced, and utterly demolished; And that no such shall hereafter be set up . . . whereunto all persons within this Kingdome . . . are hereby required at their peril to yield due obedience.[70]

Responsibility for image destruction was assigned to parish officials, notably church-wardens and justices of the peace. The degree to which it was implemented varied widely, depending upon the religious leanings and reforming energy of the locals, or the presence of Parliamentarian troops with time and appetite for destruction. Consequently, in much of the country, the iconoclasm was haphazard and sporadic – not so in East Anglia.

It was the eastern counties' peculiar misfortune to have a commissioner appointed to oversee the systematic destruction of religious imagery, a man whose name has become synonymous with iconoclasm: William Dowsing.

Dowsing was a yeoman-farmer, born in Laxfield, Suffolk, in 1596. By 1643, the year of his appointment, he was living in Stratford St Mary,

across the River Stour from Dedham in Essex, a community known for its strong Puritanism. Much of his personal library survives, a collection of religious tracts, sermons and history books, many of them peppered with his thumpingly Puritan annotations: "What is not warranted and grounded on God's word is sin"; "every ceremony is evill"; "11 evils to be reformed". A letter of 1643, written by Dowsing to the Dedham preacher Matthew Newcomen, reveals the intensity of his aversion to religious images:

> [I]f you have anie interest in parliament men, now we have an army at Cambridge it might be a fitt tyme to write to the Vice Chancellor of Cambridge & Mayor to pull down all ther blasphemous crucifixes, all superstitious pictures and reliques of popery according to the ordinances o' parliament.[71]

Dowsing would also seem to have been involved in the Parliamentarian army. A William Dowsing, very probably the same man, was appointed Provost Marshal to the armies of the Eastern Association (comprising the counties of Norfolk, Suffolk, Cambridgeshire, Huntingdonshire, Hertfordshire and Lincolnshire) in 1643, and attended on their commander, the Earl of Manchester, at the siege of King's Lynn.

It was the Earl of Manchester who in December 1643 personally appointed William Dowsing the iconoclast to enforce the destruction of religious images in the counties of the Eastern Association. Dowsing's authority derived from the Earl's, as military commander in the region; it is surely no coincidence that his destructive activities apparently ended in Autumn 1644, when the Earl of Manchester fell from favour.

The appointment of "a Parliamentary Visitor for demolishing the superstitious pictures and ornaments of churches" seems to have been unique to the eastern counties. "No similar commission for any other county or association has survived, and there is no evidence of any other person or group of persons undertaking a similar task."[72] Though Dowsing's commission from the Earl of Manchester was framed to cover all the counties of the Eastern Association, the journal in which he recorded his work only mentions locations in Cambridgeshire and Suffolk. It is unclear how organized the iconoclasm was outside those counties, though there is evidence that a deputy of Dowsing's may have overseen destruction in the south of Norfolk (iconoclasm appears to have been less severe in the north of that county).[73]

Dowsing lost no time in setting about his work. The Earl of Manchester commissioned him on 19 December 1643. The next day, accompanied by Parliamentarian soldiers, he visited the chapel at Peterhouse College, Cambridge, recording:

> We pulled down two mighty great angells, with wings, and divers other angells, and the 4 Evangelists, and Peter, with his keies on the chappell door and about a hundred other chirubims and angells and divers superstitious letters in gold.[74]

Between December 1643 and October 1644, Dowsing and his deputies visited more than 250 churches in Suffolk and Cambridgeshire, charging each church a noble (a third of £1) for their destructive work. Their targets were religious images (whether in glass, wood, stone or on canvas), altar rails and steps (considered offensive for the division they enforced between congregation and celebrant) and crosses and inscriptions calling upon the living to pray for the dead. As the enormity of his task became apparent, Dowsing's method soon became to destroy what could be dealt with easily during his visit (stained glass being the most immediately vulnerable target) and to leave orders for the removal of more time-consuming items, such as roof angels, following his departure.

Thus, from the journal, Dowsing's entries for Madingley in Cambridgeshire, and Southwold in Suffolk:

> Madingley 6 March 1644: There was 31 pictures superstitious, and Christ on the Cross, and the two thieves by him. . . . *14 cherubims in wood to be taken down, which promised to be taken down.*

> Southwold April 8, 1644: We brake down 130 superstitious pictures; St Andrew; and 4 crosses on the four corners of the vestry; *and gave orders to take down 13 cherubims; and to take down 20 angels.*

Madingley's roof angels were duly removed. Several of them, variously defaced and decapitated, are now displayed on the walls of the bell tower at the church. The angels in the nave at Southwold were left in place, but decapitated (the heads have since been replaced). The angels in the chancel there are entirely Victorian replacements.

It would be wrong to assume that *all* iconoclasm in Suffolk and Cambridgeshire was the work of Dowsing and his deputies. Local churchwardens and communities undertook destruction themselves, as did bands of Parliamentarian soldiers. Angel roofs were attacked at many churches that Dowsing does not mention in his journal, perhaps because he knew that they had already been visited by iconoclasts. In Suffolk, these include Lakenheath (angels defaced), Gislingham (angels decapitated), Bardwell (twenty-two of twenty-six angels removed), Bacton (angels removed from the ends of the hammer beams), Palgrave (angels removed), Earl Stonham (angels decapitated), Kersey (angels decapitated) and Little Whelnetham (angels decapitated, heads subsequently restored). In Cambridgeshire, Ellington's angels were defaced, but Dowsing does not record a visit.

Fortunately, even in Cambridgeshire and Suffolk, many angel roofs escaped destruction. For reasons that are unclear, Dowsing left much of north Cambridgeshire and the Isle of Ely unvisited (the roofs at Isleham and March are notably undamaged). Even where Dowsing left instructions for the removal of roof angels, these were not always followed:

> Blythburgh April 9, 1644: There was 20 superstitious pictures; on the outside of the church 2 crosses one on the porch and another on the steeple; *and 20 cherubims to be taken down in the church, and chancel.*

To deface or decapitate roof angels, let alone to remove them entirely, required time, zeal and determination. The people of Blythburgh in Suffolk chose not to comply with Dowsing's instructions, for the angel roof there, which still bears its original colour, remains largely intact, and is amongst the most magnificent in all East Anglia.

Photographs

. . . few lovers of ancient woodwork appear to study the roofs of the churches they visit, and it is strange how many otherwise admirable accounts of mediaeval buildings either fail to mention the roofs at all, or describe them in such a dubious and uncertain way that their account is almost unintelligible.

<div align="right">

F.E. Howard and F.H. Crossley
English Church Woodwork (1917)

</div>

The roof of any building was a carpenter's test and the place he could best show his imaginative understanding of invisible forces. Composed of rafters, collars, purlins and tiles, the roof was usually the heaviest part of the building not directly pegged to the ground. It exerted the strongest forces, both straight down and outward. And it was always the part most exposed to wind and storm. Each member of a roof truss – the triangular . . . assembly of rafters and tie beams – is a force made visible. Gravity flows down the roof rafters and pushes at the walls on which the roof sits. The tie beam resists, holding the two pieces in tension. Above the tie beam, the carpenter places a collar – a smaller and higher version of the tie beam – to siphon off some of gravity's pull. Beneath the collar a post or pair of arched braces would let the forces cascade down to the centre of the tie beam. Beneath the tie beam, more arched braces led out to a lower level of the walls, letting the forces run out into the ground.

<div align="right">

William Bryant Logan
Oak: the Frame of Civilization (2006)

</div>

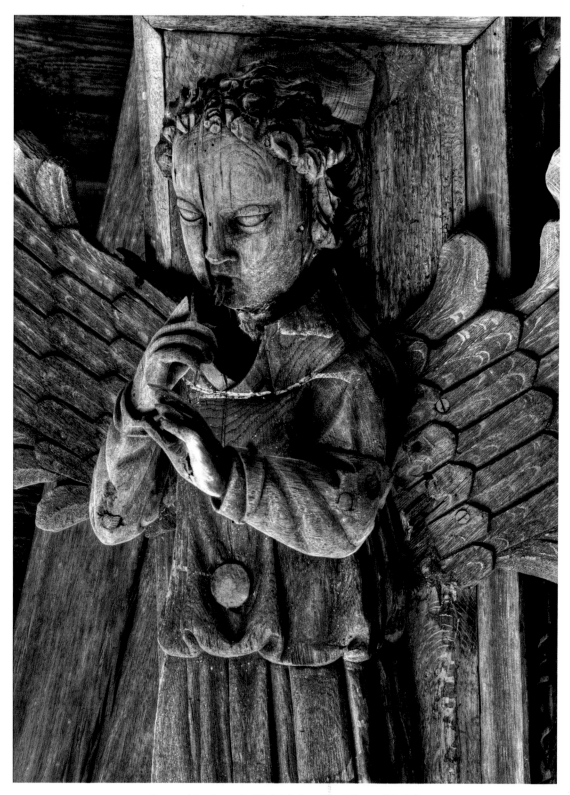

An angel in the roof of St Nicholas, King's Lynn, Norfolk,
plays a wind instrument, now lost.

A Note on the Photography

ANGEL ROOFS PRESENT PHOTOGRAPHIC challenges, due to their distance and low light or, when they are illuminated by clerestory windows, extremes of light and shade.

The photographs in this book were taken from ground level, using ambient light or, occasionally, the installed church lighting, and a range of lenses: wide angle to capture the full run of a roof, and telephoto for detail. Exposure times varied from under one second to as much as eight seconds, depending on light conditions. All the photographs were taken with a digital camera, a Nikon D300S.

Where available light is low, it can be almost impossible to discern the detail of an angel roof with the naked eye. This is where photography has a particular advantage. The eye relies on the immediately available light, but in a photographic exposure, light accumulates on the camera sensor with time, and so longer exposures make a dark subject brighter in a way that the eye cannot.

Most of the photographs in this book are the product of a single exposure. However, in a few cases, where the range of light and dark was too wide to be captured in a single shot, I used High Dynamic Range Imaging (HDR), a technique in which three or more shots of the same subject are taken at different exposures (one optimized for the shadows, one for the highlights and one for the mid-point of the contrast range) and then bonded together using HDR software. This produces a single image optimized across the contrast range, preventing the highlights from blowing out and the shadows from being underexposed.

Westminster Hall, London

OPPOSITE PAGE:

*The angel roof at Westminster Hall, showing the huge timber arch ribs
and the projecting hammer beam angels.*

This, the earliest known angel roof, is the work of Hugh Herland (c. 1330-1411), master carpenter to Richard II. It was installed mainly between 1395 and 1398 as part of the restoration of Westminster Hall for the king.

It is the largest medieval timber roof in northern Europe, with a span of 68 x 240 feet. It has been estimated that the roof timbers alone weigh over 660 tons. A masterpiece of art and engineering, it uses a combination of timber arches and hammer beams to provide rigidity without the need for columns, thus leaving the floor space in the Hall entirely open.

The twenty-six hammer beams are carved into the shape of full-length angels bearing shields blazoned with the arms of Richard II. They project horizontally from the wall plates, intersecting the arch ribs and stretching beyond to support vertical hammer posts which again connect with the curved ribs higher up. Many of the structural forms used by Hugh Herland at Westminster are also employed in the angel roofs of East Anglia.

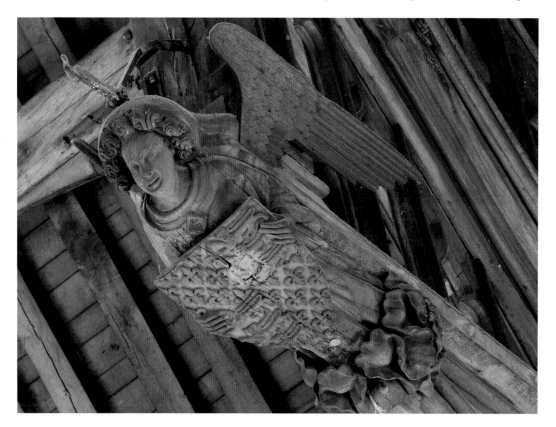

ABOVE:

A close-up of one of the hammer beam angels.

The twenty-six hammer beam angels in the roof at Westminster Hall bear the arms of Richard II (the lions of England quartered with the *fleur-de-lys* of France) and are the work of expert figure carvers.

We know the names of four of them, and what they were paid (see p. 16). The individual carvers' hands are evident in the different ways hair, facial features and drapery are rendered.

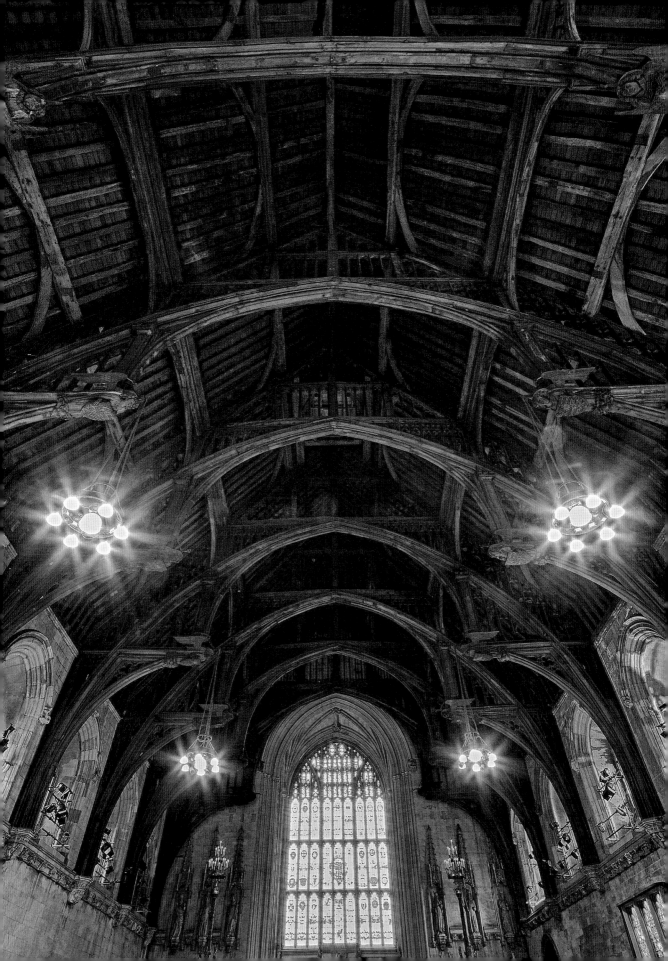

St Botolph, Banningham, Norfolk

Rebuilt in the fifteenth century, St Botolph has a single hammer beam roof with long wall posts. Fourteen half-angels adorn the undersides of the hammer beams. The spandrels (the pierced, fretwork-like sections above the hammer beams) are particularly elegant. Those at the east end, at the top of this image, have masterful carvings of angels swinging censers. The angels were repainted in the 1950s.

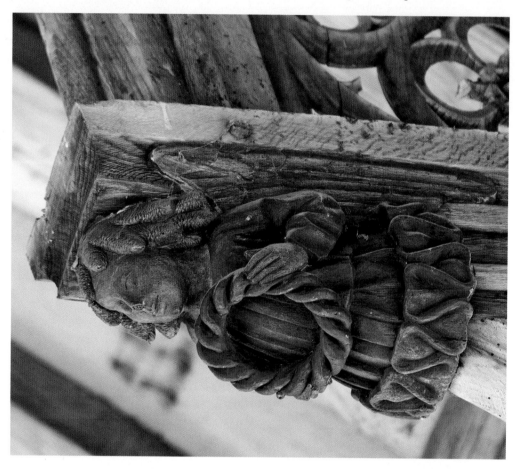

ABOVE:

*A half-angel on the end of a hammer beam bears
the crown of thorns of Christ's Passion.*

The crown is rendered as a padded torque, which probably reflects the costuming conventions of medieval mystery plays and religious dramas. The figure emerges from a base of undulating, fabric-like folds. Actors who played angels in mystery plays often stood in raised "pulpits" that obscured the lower half of their bodies, and were edged with folds of fabric or fluffy "clouds" of wool. The props and costuming conventions of medieval dramas and pageants appear to have influenced carvers' depiction of angels. The angel's hair is distinctively carved as a series of pine-cone-like ringlets. A similar style is used for the hair of some of the angels in the roof at St Mary, Wiggenhall St Mary, in Norfolk, though those look like the work of a different carver. The colour on this carving dates from the 1950s restoration.

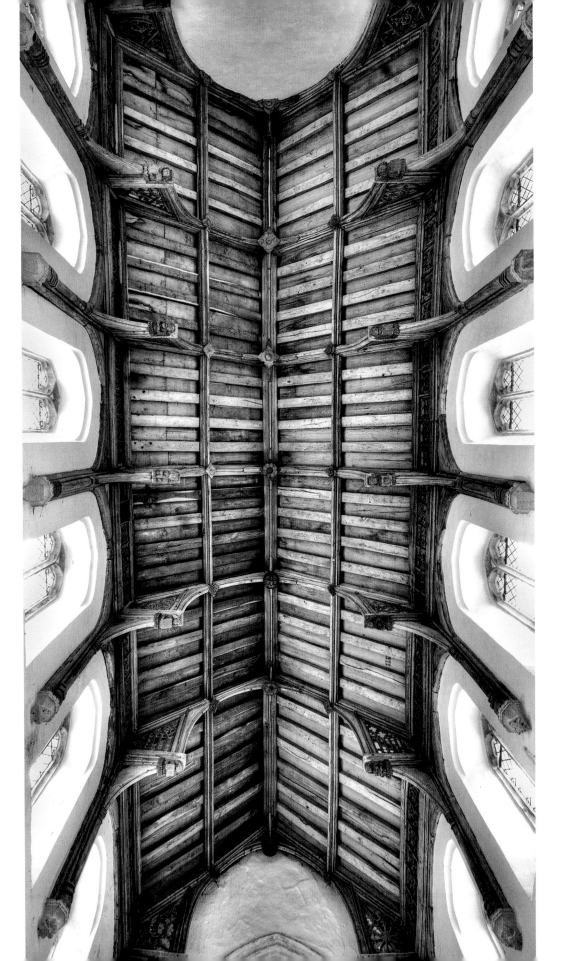

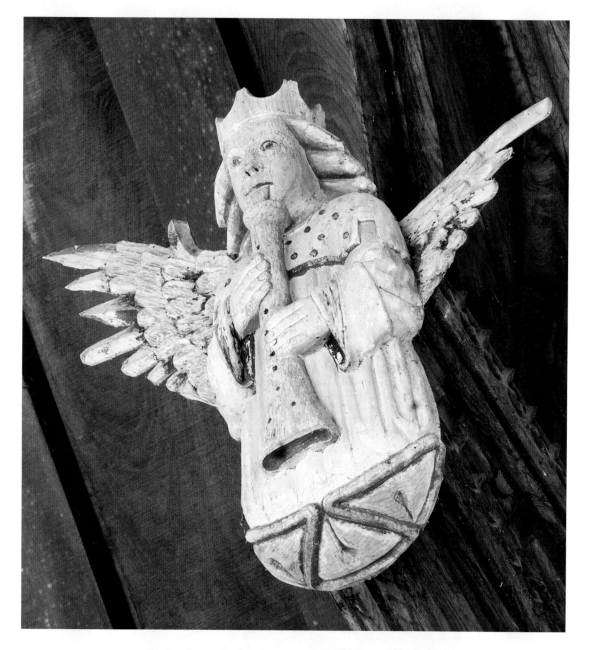

St Andrew, Burlingham St Andrew, Norfolk

*A demi-angel on the end of a hammer beam plays a shawm,
a predecessor to the modern oboe.*

The two holes in the bell of the instrument are tuning vents; the disc at the mouthpiece end is called a pirouette. The shawm was played with high wind pressure, pressing the lips against the pirouette to reduce air leakage. The faded paint on the figure is believed to be original. The roof is an arch brace and hammer beam structure; a bequest dates it to 1487.

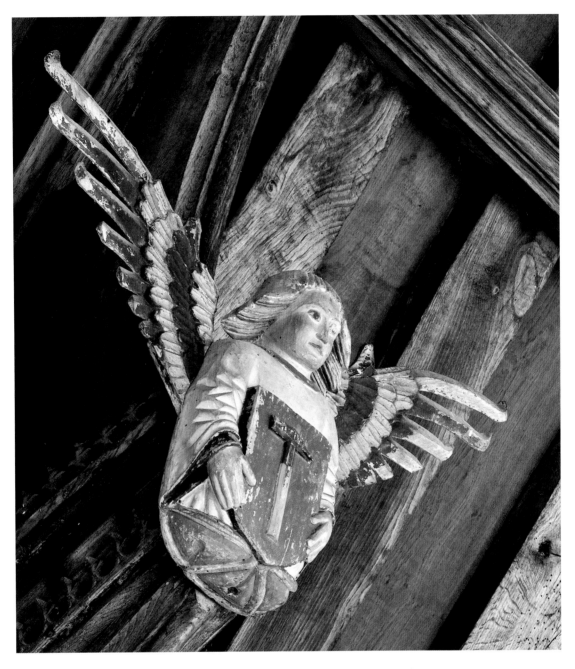

A close-up of a demi-angel at St Andrew,
likely to be a Victorian replacement.

St Agnes, Cawston, Norfolk

Opposite Page:

One of the most magnificent and imposing of angel roofs.

St Agnes' roof is a steeply pitched single hammer beam construction, spectacular in its scale, the quality of its sculpture and secondary detailing, and its lavish use of timber. St Agnes' angels are over 6 feet tall from feet to wingtips, and, uniquely, stand upright on the hammer beams. The tracery in the spandrels above and below the hammer beams is superb, and demi-angels line the horizontal wall plates. No expense has been spared.

St Agnes was built in the late fourteenth century by Michael de la Pole, Earl of Suffolk, who died at the siege of Harfleur in 1415. His immediate heir fell at Agincourt five weeks later – one of the few high status English casualties of the battle – and the title passed to the second son, William. As chief adviser

to the ineffectual Henry VI, William de la Pole was, by the 1440s, the most powerful man in England, becoming first Marquis and then Duke of Suffolk. It is tempting to assign the creation of so spectacular a roof to the de la Poles, and to see it as an assertion of their influence in the region. However, archaeological evidence (the line of an earlier roof on the wall of the church tower) argues against a date during the years of de la Pole power, though stylistically such a date is plausible. From bequests we know that internal refurnishing of the church was being undertaken in the 1460s (William de la Pole fell from power and was murdered in 1450), and Michael Begley has suggested to me in correspondence that the angel roof is more likely to date from 1470-80.

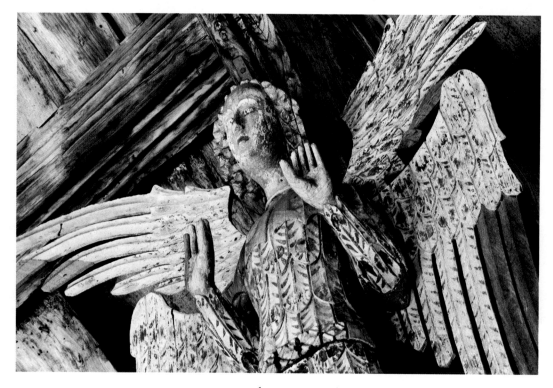

Above:

A roof angel stands upright on a hammer beam,
clad in a suit of feathers.

We know that medieval actors portraying angels in pageants and mystery plays wore bodysuits like this, with the "feathers" made of tabs of coloured cloth

or gilded leather. The faded paint on the figure is believed to be original. The palette of white, red, green and black is also found in other roofs in the region.

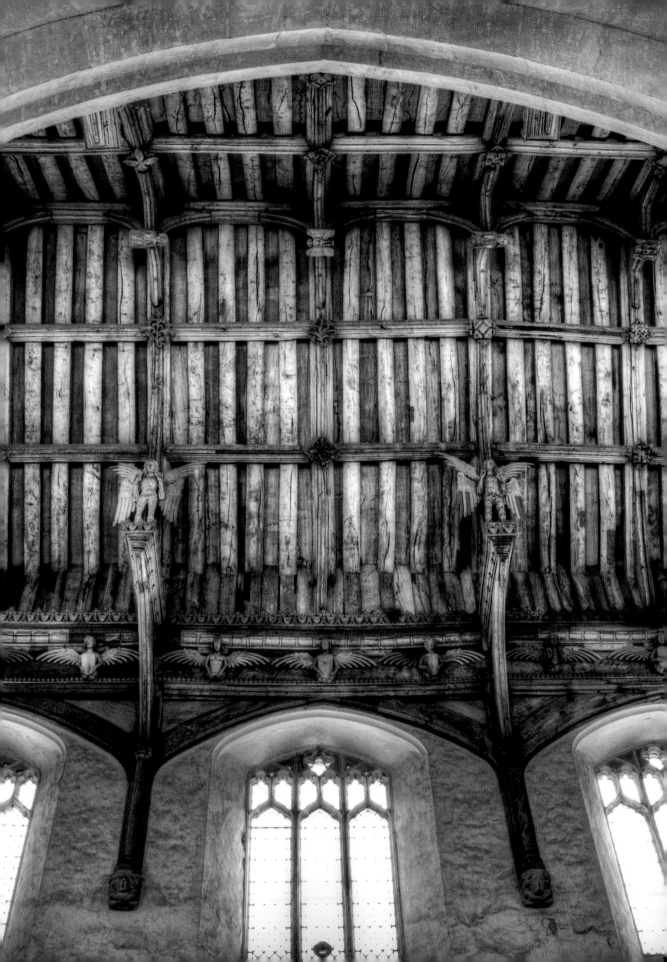

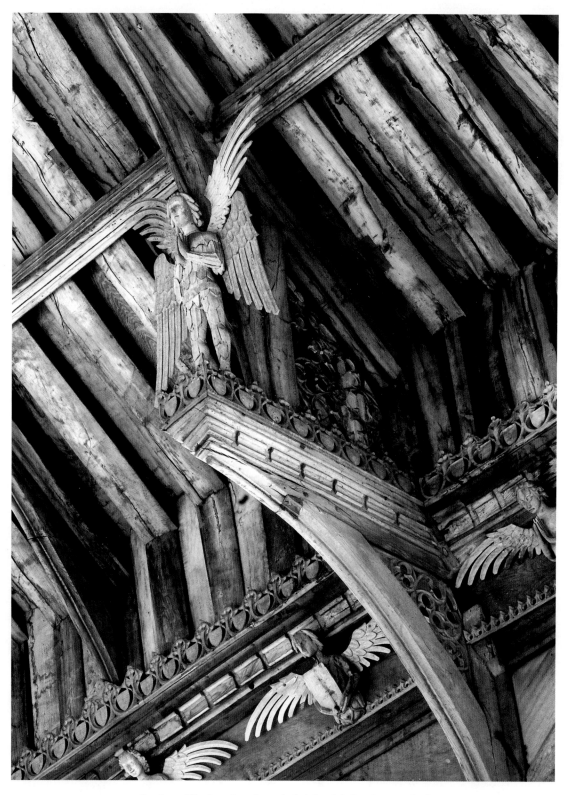

Another of St Agnes' roof angels (with a height of over 6 feet)
stands upright on a hammer beam.

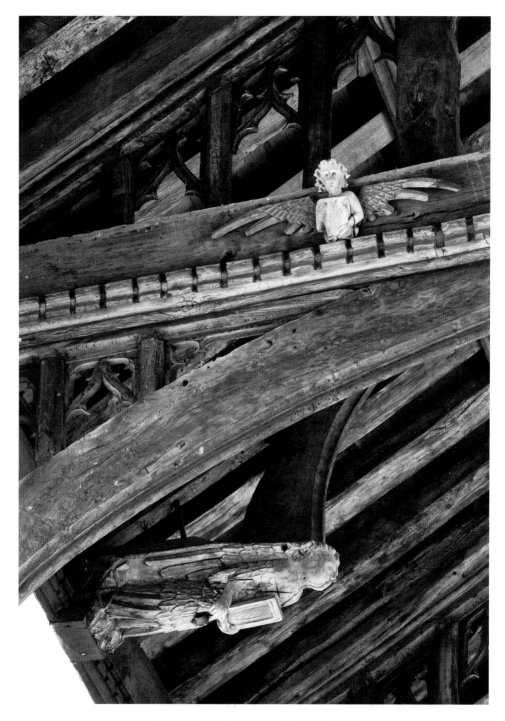

St Edmund, Emneth, Norfolk

*A fifteenth-century angel roof of alternating tie beams and arch braces,
with demi-angels on the tie beams and horizontal, embryonic
hammer beam angels at the foot of the arch braces.*

A similar structural pattern is found at Mildenhall, Lakenheath, King's Lynn and Upwell.

St Martin, Fincham, Norfolk

The roof at St Martin,
an alternating tie beam and hammer beam structure.

The angels in the nave roof at St Martin appear mostly to be the work of a single carver, and one with a very characterful, graphic style. Wing feathers are deeply scalloped, eyes are rendered with heavily incised pupils and iris rings, hair is tousled and impressionistic, and most distinctively of all, the undersides of this carver's noses have a characteristic "arrow head" shape. Inevitably, we do not know this carver's name, but his hand is extremely distinctive. The roof here also contains a series of fabulous grotesques, amongst them several bearded, lion-esque demons. These have the same graphic exuberance as the angels, and look like the work

of the same man. The nave roof is believed to date from 1488 (See Paul Cattermole and Simon Cotton, "Medieval Parish Church Building in Norfolk" in *Norfolk Archaeology* Vol. 38, 1983, p. 247).

The wealthy Fincham family paid for much work at the church, and are the likely sponsors of the angel roof, which is an alternating tie beam and hammer beam structure. The same family had strong connections to St Clement, Outwell, in Norfolk. The roof angels there show some similarities to those in the North Aisle at St Martin, though insufficient, I think, to make them the work of the same carver.

ABOVE:

A characterfully carved roof angel at St Martin.

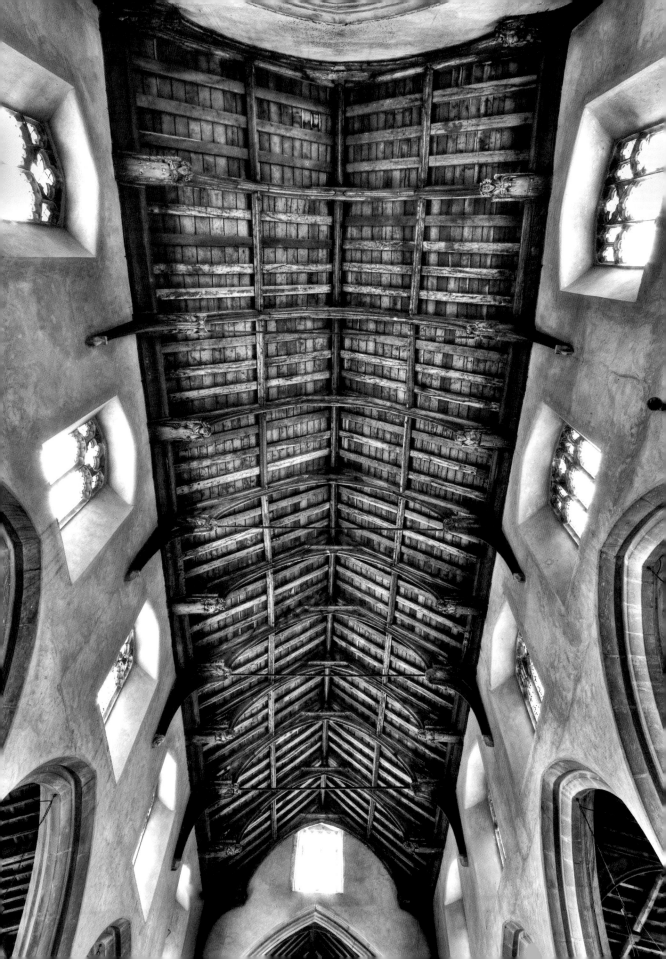

St Mary, Gissing, Norfolk

An exquisite miniature double hammer beam roof.

St Mary is a Fabergé egg of a church, small-scale, intricate, beautifully made. It has everything a church crawler could want: a round tower, a fabulous knapped flint porch, Norman arches, Saxon windows, grandiose armorial monuments, seventeenth-century whimsy and one of only four double hammer beam roofs in Norfolk and thirty-two in the country. The roof here has collar beams and king posts, which is unusual for Norfolk, but common in Suffolk. That said, Gissing is only just in Norfolk, and the roof may well have been made by a Suffolk workshop.

The half-angels on the ends of the hammer beams carry the emblems of saints, symbols of the Passion and musical instruments. The angels on the lower tiers of hammer beams seem mostly to be Victorian replacements, as do all the angels' wings. Angel wings are often replacements, since the slim tenons that attached the originals were particularly vulnerable to decay or to wilful destruction during the Reformation. Iconoclasts may well have been at work at St Mary, because in addition to the replacement of the lower tier angels, the wall posts here have all been sawn short.

The angel roof in the chancel at St Mary is not medieval, but Victorian or later.

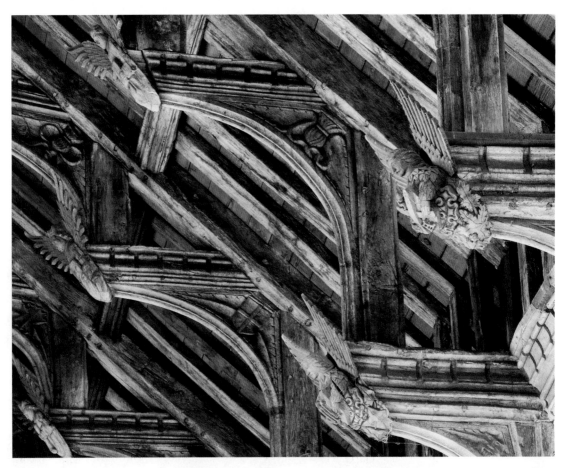

A close-up showing the two tiers of the roof.

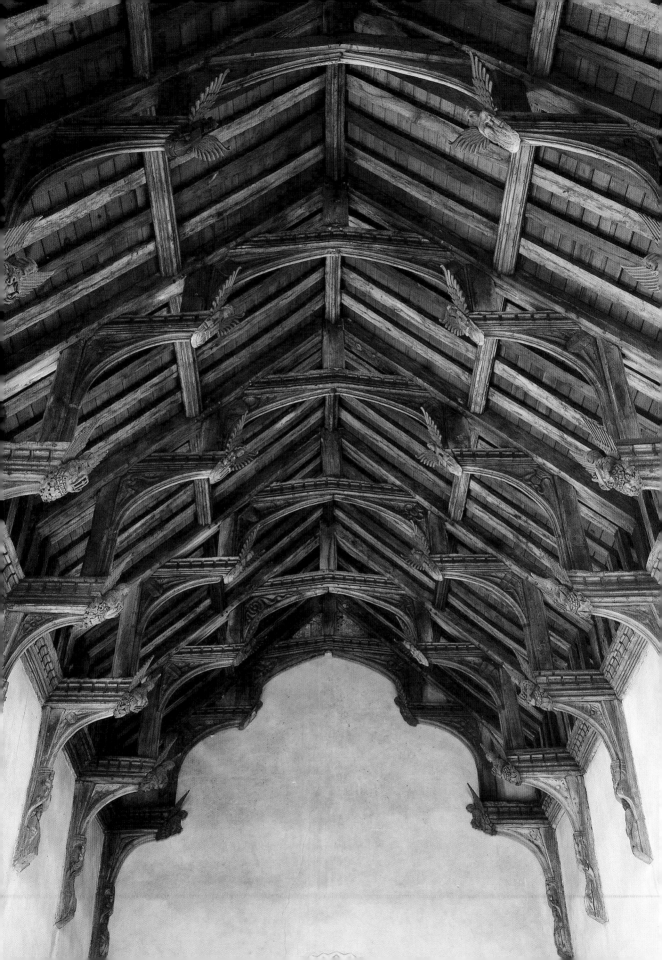

St Nicholas, King's Lynn, Norfolk

OPPOSITE PAGE:

*A spectacular arch-braced tie beam roof, with hammer beam angels between
the tie beams that are positioned at the apex of the clerestory windows
to maximize illumination on the sculptures.*

The current building is believed to date from c. 1405-10, which makes this the earliest dateable angel roof in East Anglia.

Vast and exploding with light, St Nicholas is a spectacular statement of the wealth and confidence of King's Lynn's merchant class in the early fifteenth century. Construction was funded by donations from several rich merchants, rather than by a single wealthy donor. The district in which the building stands – the "New Land" – was fashionable with merchants at the time; many chose to build their own flashily timbered houses there.

Medieval bench ends from St Nicholas, now in the Victoria and Albert Museum, London, carry detailed depictions of the merchant ships on which the town's success was based. In the early fifteenth century, King's Lynn's merchants traded with Scandinavia, Northern Europe, Gascony, Spain and even Iceland, and grand new halls for the town's leading merchant guilds were built in this period.

Despite its magnificence, St Nicholas did not have the full status of a church, but was a chapel of ease (erected for the convenience of worshippers who could not reach the parish church easily) and so lacked the right to celebrate all the sacraments. The actual church for the parish is St Margaret, about half a mile away. There would seem to have been bitter rivalry between the two sets of parishioners, because in 1378 a papal bull that gave St Nicholas full rights to celebrate the sacraments was rescinded after protests from St Margaret. Bequests indicate that fundraising for the new building of St Nicholas was underway in the 1390s. The scale and quality of the building – and its angel roof – are a magnificent riposte to the obstructive parishioners of St Margaret.

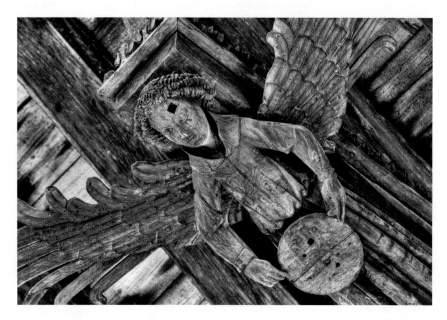

ABOVE:

An angel plays a tambourine-like instrument.

This angel, and several others at St Nicholas, appear to be the work of the same carver who made the roof angels at Methwold. The figure plays a timbre, a tambourine-like instrument. The rendering of the hair as crisp, springy ringlets and the "blind", pupil-less eyes are characteristics of this man's work.

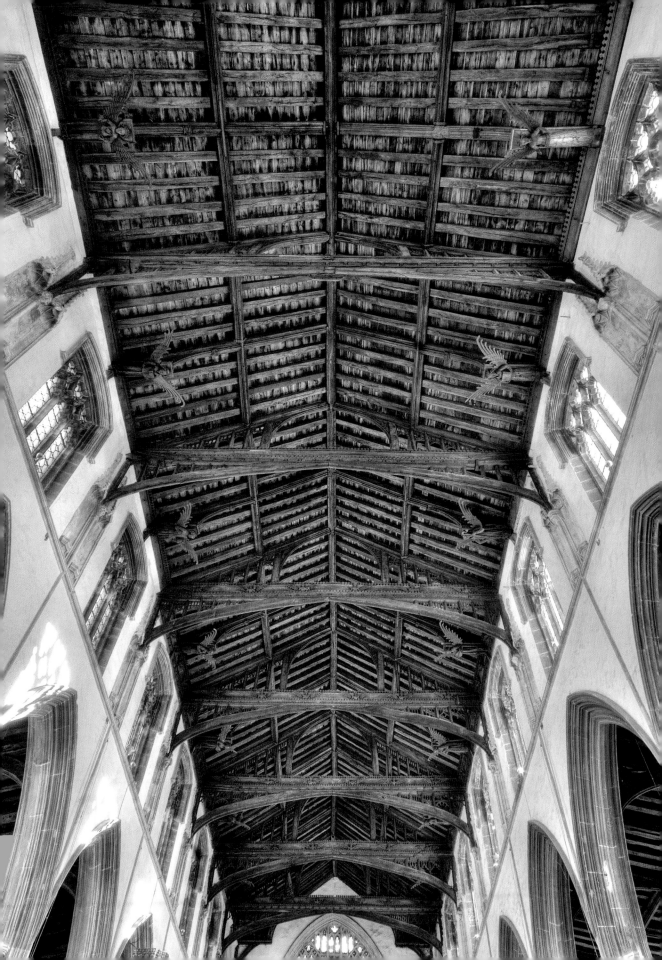

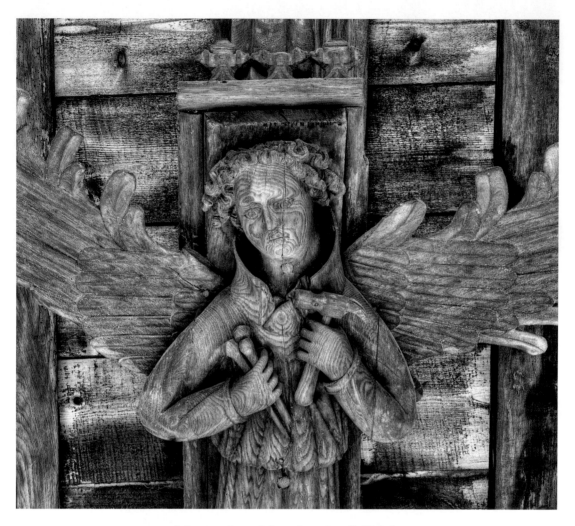

*A close-up of one of the roof angels at St Nicholas,
bearing the hammer and nails of the Crucifixion.*

Other angels at St Nicholas play a variety of musical instruments. The symbols of the Passion and musical instruments are both recurrent themes in angel roofs. Originally the angels would have visually interacted with the rood – the sculptured group of Christ crucified, flanked by Mary and St John. These spanned the chancel arch in churches until the Reformation led to their destruction.

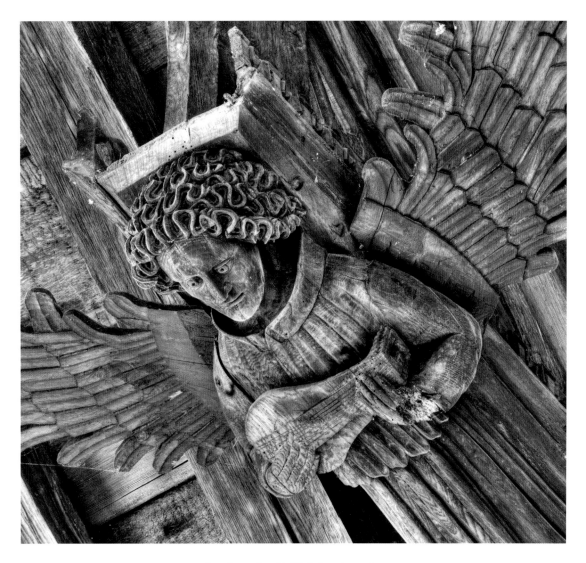

A roof angel at St Nicholas plays a lute.

The roof angels at St Nicholas are the work of at least three different carvers, each with very different styles. Here, an angel plays a lute. This carver renders hair very distinctively, in deeply recessed, undulating hanks, which to my mind look rather like intestines, while his eyes have heavily incised pupils and iris rings. The hand of the same "Intestinal Hair Carver" can be seen in some of the angels at St Mary, Mildenhall, in Suffolk, a roof that probably dates from the 1420s.

St Peter and St Paul, Knapton, Norfolk

OPPOSITE PAGE:

A double hammer beam massed angel roof
dating from 1504.

70 feet long and over 30 feet wide, the roof was (according to Mortlock and Roberts in *The Guide to Norfolk Churches*) endowed by John Smithe, who was rector at St Peter and St Paul from 1471-1518.

The roof beams and wall plates are adorned by 138 angels, with the lower hammer beam angels probably having been restored. The roof is unusual for Norfolk, in that it has collar beams (horizontal beams near the apex that connect the principal rafters and help to counteract spread). Collar beams are common in Suffolk double hammer beam roofs, and so it has been suggested that St Peter and St Paul's roof was made in a Suffolk master's workshop, and transported to north Norfolk by water. Water was preferable to road for transporting heavy loads in the Middle Ages, and Knapton is only a few miles from the coast.

Massed angel roofs of this kind major on overwhelming dramatic effect, rather than the delicacy of the individual angel carvings. The carpentry here is particularly elegant; the upper tier of hammer beams is supported by sweeping arch braces which are jointed into the rafters and the hammer posts of the lower tier, and echo the arch braces that underpin the lower set of hammer beams.

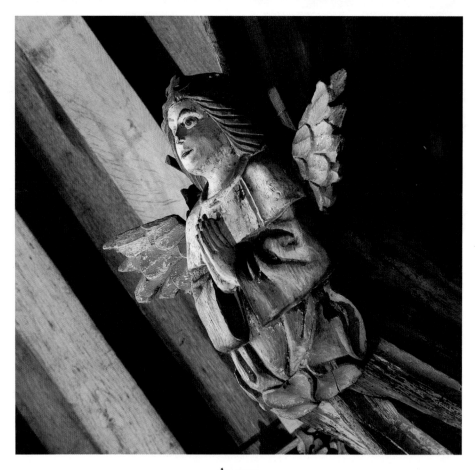

ABOVE:

An angel on one of the lower hammer beams.
The figure has been repainted.

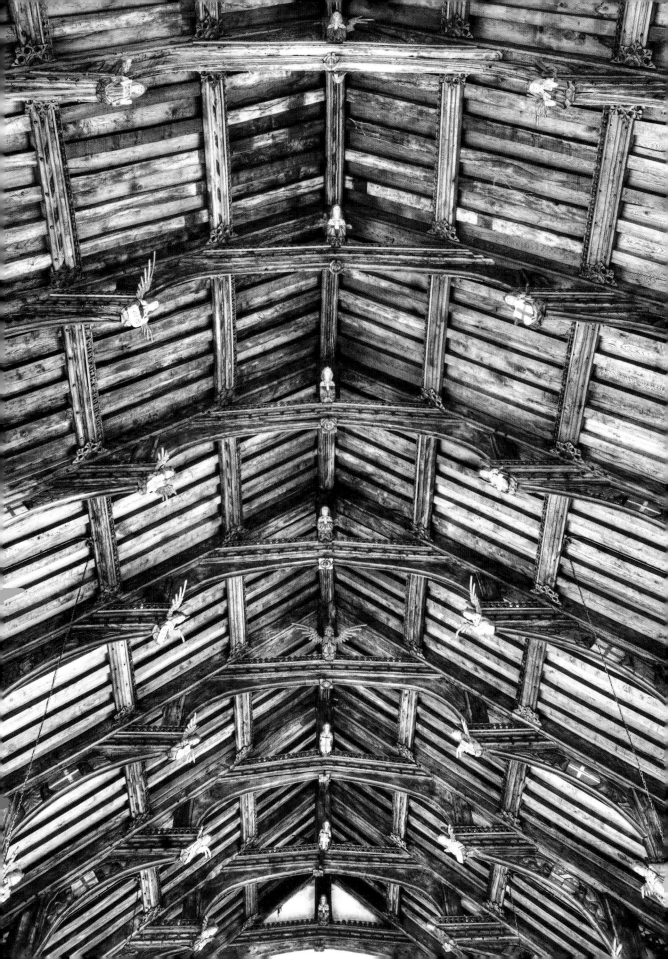

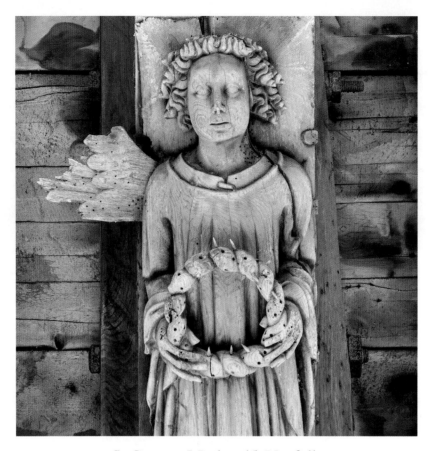

St George, Methwold, Norfolk

An angel bears the crown of thorns, a symbol of Christ's Passion.

The structure of the nave roof at St George (four bays, divided by alternating tie beams and hammer beams) suggests that there were originally eight angels here. Only five survive, their wings reduced to ragged stumps by decay or iconoclasm, but they are some of the finest examples of medieval figurative carving in the country, and they all appear to be the work of the same hand.

We will probably never know the name of the man who carved St George's angels, but he was an artist of great delicacy and one with a very distinctive style. The hair is modelled in crisp, springy ringlets, the cheeks have such pliancy that one feels they would dimple to the touch and the drapery over the angel's arm is so light and fluid one half expects it to stir in the breeze.

But though his name is lost, the distinctive hand of the "Methwold Master" can be seen at another location in Norfolk; he plainly carved several of the angels at St Nicholas, King's Lynn (shown elsewhere in the book), which share the same stylistic "tells". The roof at St Nicholas, the earliest dateable angel roof in East Anglia, was erected c. 1405-10. This strongly suggests that St George's roof dates from some time in the first quarter – or at the outside, the first half (depending on how long the Methwold Master was active) – of the fifteenth century.

The angel carries the crown of thorns, a symbol of the Passion of Christ. Another figure in the roof of St George carries the nails of the Crucifixion. Emblems of the Passion are a recurrent theme in angel roofs, and a reminder of how the angels once interacted with the rood sculpture of Christ crucified which – until the Reformation – spanned the chancel arch of every church in England.

The crown of thorns is rendered as a padded torque with spikes, probably copying the costuming conventions of medieval mystery plays. Some of the original "thorns" are still there, set in place by a nameless craftsman over 500 years ago.

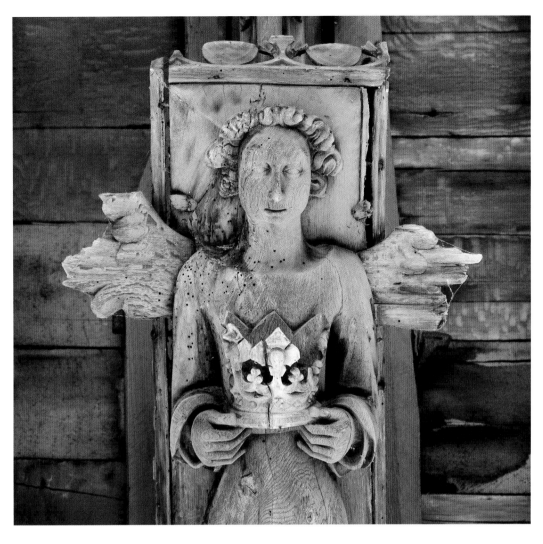

Another of the five surviving angels at St George,
Methwold. A female angel bears a crown.

This figure, a female angel, carries a beauti-fully rendered crown, perhaps symbolizing the coronation of Christ as King of Heaven, or of the Virgin Mary as celestial Queen. There is a similar crown-bearing female angel in the roof of St Mary, Bury St Edmunds, dating from c. 1444-5 (carved by a different craftsman, and shown elsewhere in this book). A plausible case can be made for the Bury figure having a dual connotation as both a depiction of Mary, Queen of Heaven, and an expression of support for the forthcoming marriage (solemnized in May 1445) of Margaret of Anjou to the Lancastrian King Henry VI. The marriage was pivotal in William de la Pole's efforts to make peace with the French

and so cling on to the few English territories remaining from Henry V's conquests.

As explained in the caption to the previous photograph, St George's angels were probably carved in the first half of the fifteenth century, though we cannot attach a more precise date within this range – and so a possible allusion to Henry VI's marriage – to this roof.

The manor of Methwold passed to Thomas, Earl of Lancaster, in the mid-fourteenth century and then, through Henry IV's usurpation in 1399, to the Lancastrian monarchs. It was thus a royal possession at the time the roof was erected. The Queen – via the Duchy of Lancaster – is still lord of the manor of Methwold.

All Saints, Necton, Norfolk

*The angel roof at All Saints, Necton,
which was restored in 1982.*

It alternates tall, sweeping arch braces with carved angel hammer beams. The faded colour on the roof may be original. While most angel roofs are fashioned from oak, the angels at All Saints (like those at St Peter and St Paul in nearby Swaffham) are made of chestnut, which is softer to work than oak, and much more resistant to insect attack.

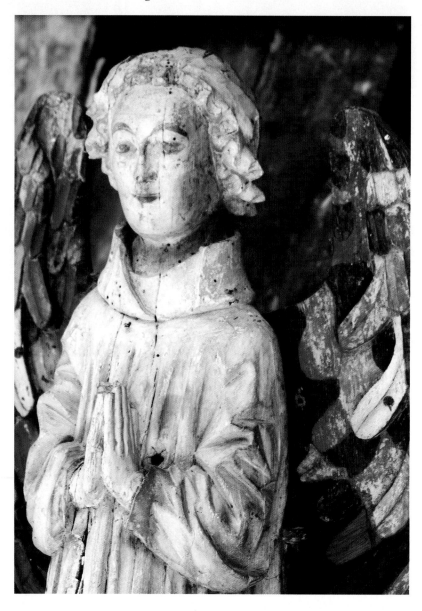

ABOVE:

*A close-up of a fifteenth-century hammer beam angel.
This is fairly high quality carving; the clothing, hands and hair are well modelled.*

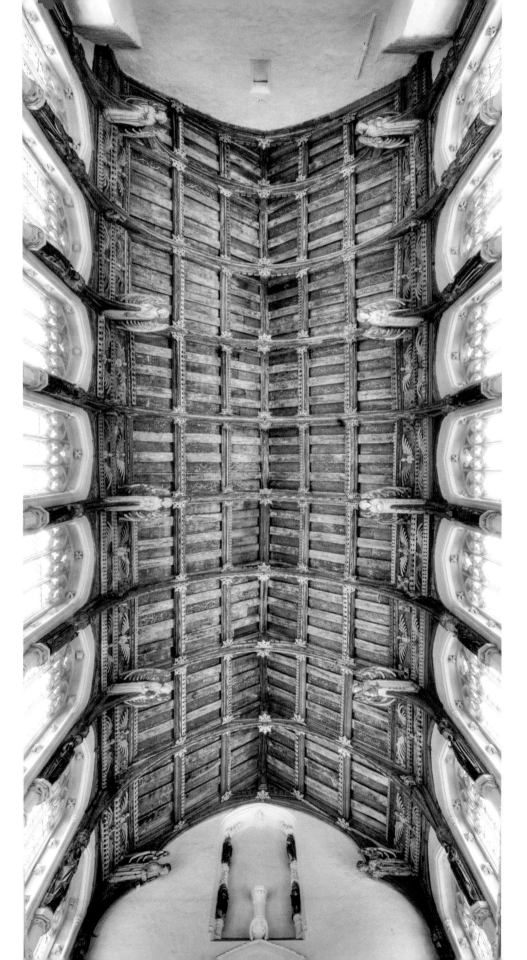

St Mary, North Creake, Norfolk

OPPOSITE PAGE:

*A single hammer beam roof with long wall posts
set between the clerestory windows*

The hammer beam angels carry the symbols of the Passion, musical instruments and, in one case, a diminutive figure which may be intended as a departed soul. The figures have lost their wings, but marks on the box-like structures that back them show where they once were. The wall plates, which run along the base of the roof, are heavily ornamented with low relief carvings of demi-angels.

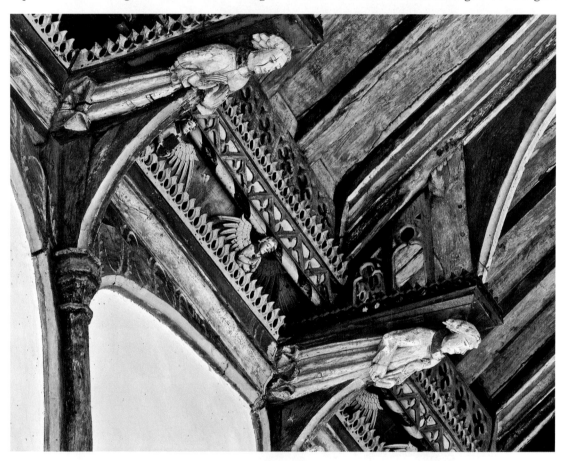

ABOVE:

A close-up of two of the roof angels at St Mary.

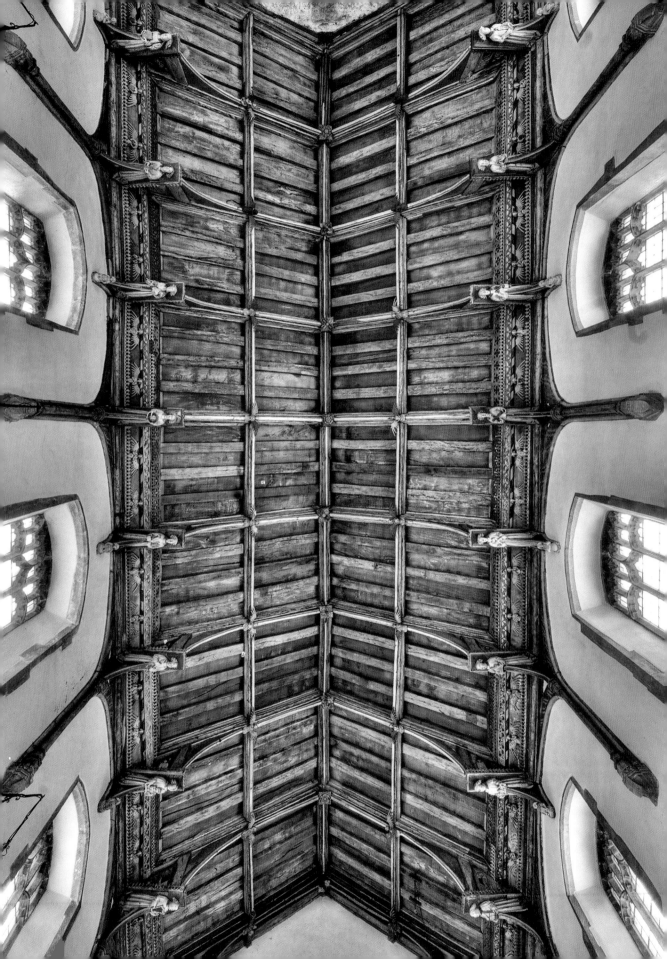

St Peter Mancroft, Norwich, Norfolk

OPPOSITE PAGE:

The angel roof at St Peter Mancroft, Norwich,
with its elegant timber fan vaults.

St Peter Mancroft was built between 1430 and 1455 on the site of an earlier structure. Its scale and magnificence reflect the affluence of Norwich in the fifteenth century; for much of the period, it was the largest city in England after London. The roof is a spectacular piece of carpentry; cosmetic fan vaults rendered in wood, but mimicking stone, conceal structural hammer beams. This timber fan vaulting is also found in the angel roof at St Peter, Ringland, in Norfolk.

The clerestory, with seventeen windows on each side, makes the church very bright and airy. St Peter Mancroft boasts one of five surviving angel roofs in Norwich. The others are St Michael at Plea, St Peter Hungate, St Giles and St Mary Coslany.

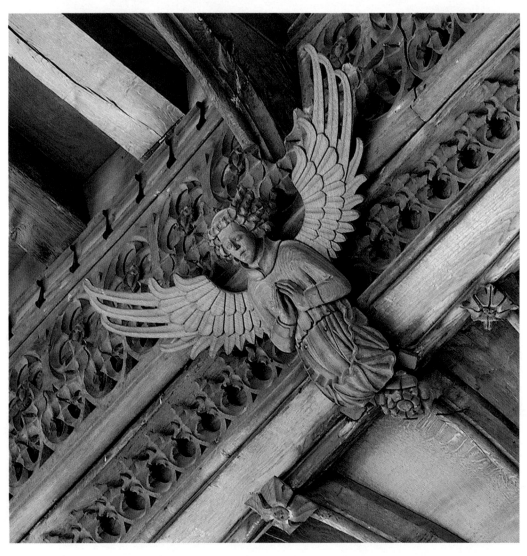

ABOVE:

A close-up of a roof angel at St Peter Mancroft.

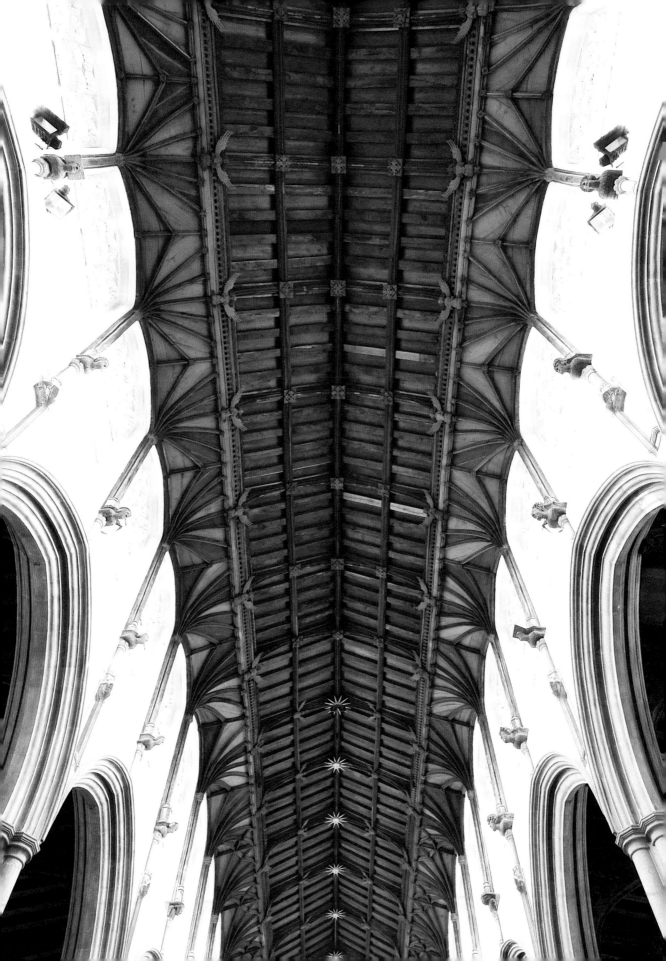

St Clement, Outwell, Norfolk

OPPOSITE PAGE:

A roof angel tenderly carries a soul.

St Clement, Outwell, close to the border with Cambridgeshire, has roof angels in the nave, the transept chapel and the south aisle, all in very different styles. In the Middle Ages, the church had connections with the wealthy Fincham family, and the south aisle angels bear some similarity to those at St Martin, Fincham, though not enough, I think, to say that they are by the same hand. Here, an angel carries a soul – shown as a diminutive, praying figure – in a cloth.

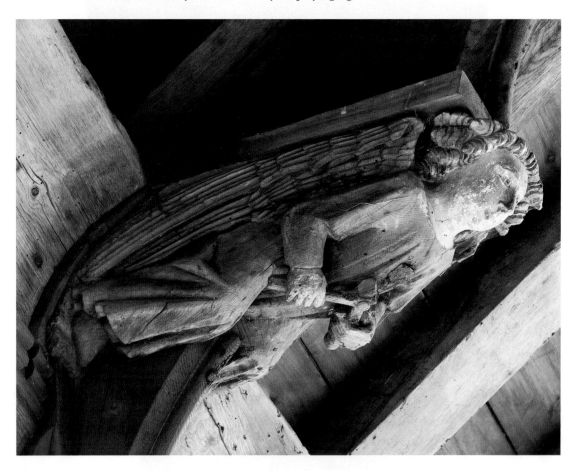

ABOVE:

*One of the hammer beam angels carries pincers,
a symbol of Christ's Passion.*

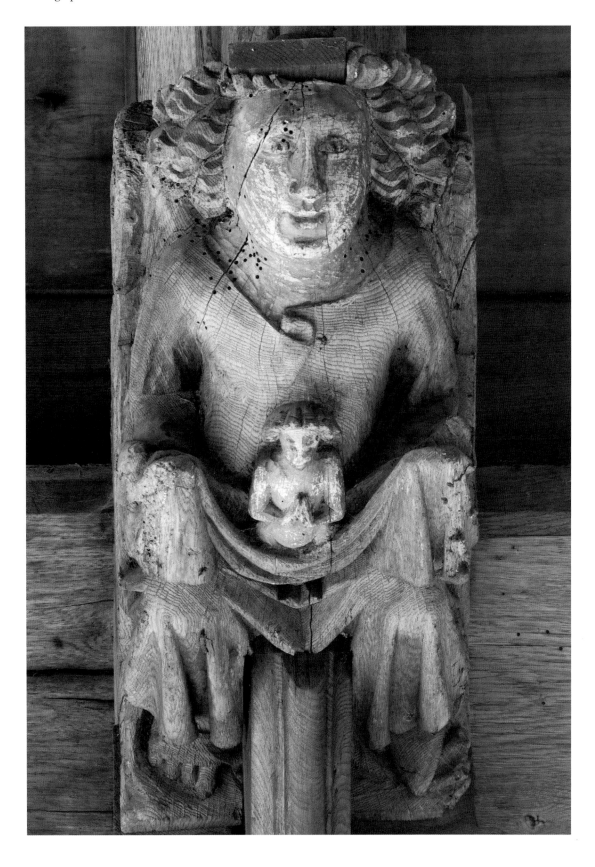

St Peter, Ringland, Norfolk

*A perfect, small-scale angel roof –
virtuoso work by an unknown fifteenth-century carpenter.*

St Peter's roof – like that at St Peter Mancroft in Norwich – recreates masonry fan vaults in wood. The same craftsman may have made both; certainly the roofs are of very similar design. Behind the elegant timber vaults are hidden hammer beams; half-angels carved in low relief are positioned on the beautifully fretted fascia at the points where the concealed hammer beams terminate. In *The Guide to Norfolk Churches*, Mortlock and Roberts aptly describe St Peter as, stylistically, St Peter Mancroft's "younger sister . . . so small, so compact . . . simply and inevitably beautiful". The dust jacket of Munro Cautley's *Norfolk Churches* shows a watercolour of the exterior.

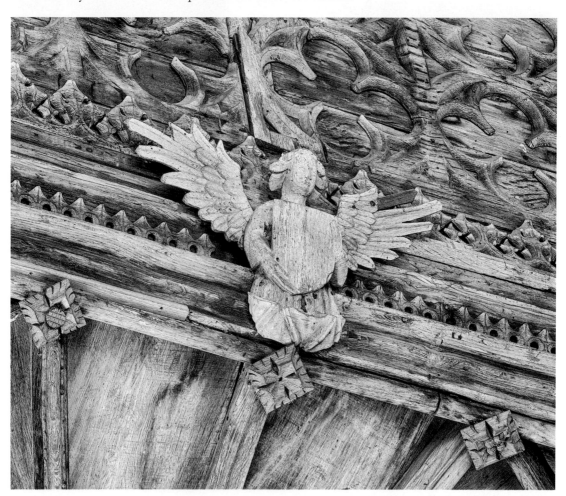

ABOVE:
A fifteenth-century demi-angel on the roof fascia.

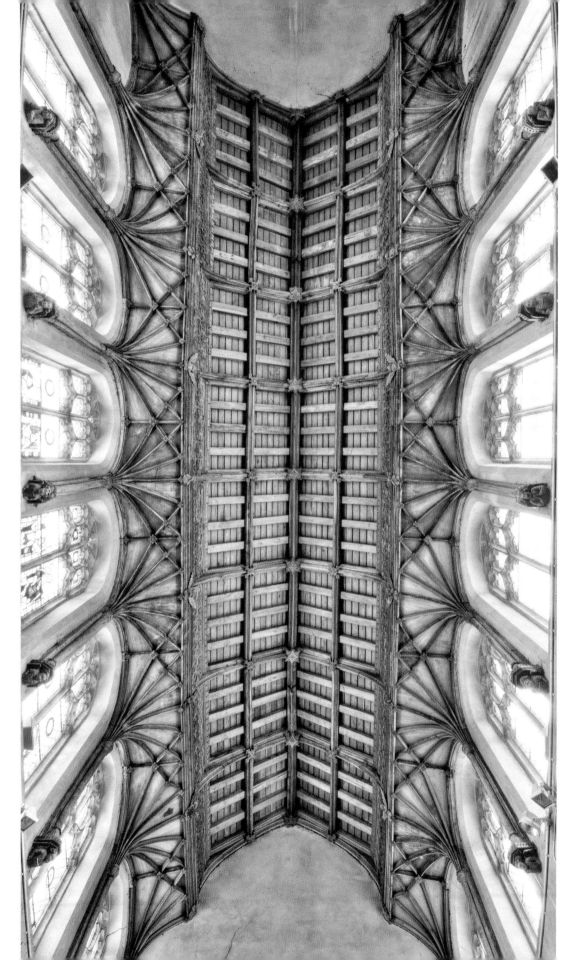

St Mary, South Creake, Norfolk

OPPOSITE PAGE:

Roof angels look down on a (restored) rood at St Mary.

This photograph gives an impression of how roof angels originally interacted with the rood figures that occupied the chancel arch in churches until the Reformation.

The rood here is a Victorian replacement, the work of the architect Sir Arthur Blomfield, and was made not for St Mary, South Creake, but for St Mary, Colchester. His other works include the Royal College of Music in London and the restoration of the spire of Salisbury Cathedral. Thomas Hardy worked as assistant architect in Blomfield's practice in the 1860s, and the two became good friends.

The angel roof at St Mary is an early single hammer beam structure with arch braces, the hammer beams carved into angels. The nave and arcades were rebuilt in the early years of the fifteenth century, and at least part of the work was funded by a bequest from the will of John Buckenham (1412). The angel roof itself was reputedly raised in celebration of Henry V's victory at Agincourt (25 October 1415), and so may well date from the period 1415-20. The angels were restored and repainted in the 1950s. While the wings are replacements, the bodies are original and contain traces of lead shot, the result of seventeenth-century attempts to rid the church of an infestation of jackdaws.

Roof angels here carry the arms of Edward, the Black Prince (victorious over the French at Crécy in 1346), musical instruments and the symbols of Christ's Passion.

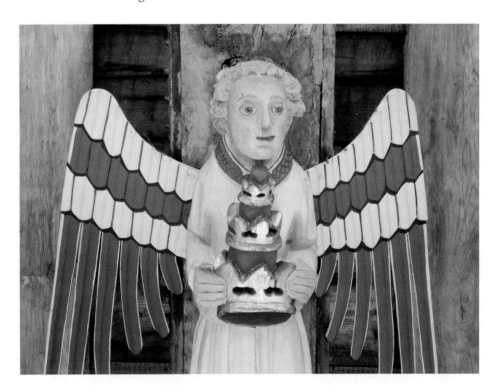

ABOVE:

*One of the angels at St Mary holds the triple crown
of St Edmund of East Anglia.*

The crown symbolizes (according to John Lydgate's *Life of St Edmund*) St Edmund of East Anglia's martyrdom, virginity and kingship. The triple crown standard of St Edmund was one of the banners carried by Henry V's army at Agincourt.

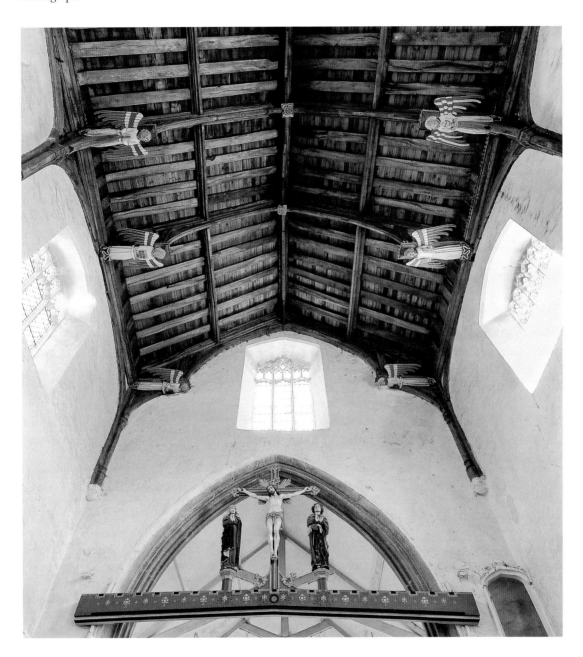

St Peter and St Paul, Swaffham, Norfolk

OPPOSITE PAGE:

*A view of the false double hammer beam roof
with its massed angels.*

One of the most magnificent in Norfolk, this roof is a false double hammer beam construction (i.e. only the lower hammers actually bear load), adorned with 192 angels on the wall plates and the ends of the hammer beams. The photograph shows both tiers of angel hammer beams; note how those in the upper "false" tier do not connect to the rafters above them. Like the roof angels at All Saints in nearby Necton, St Peter and St Paul's angels (and perhaps the entire roof) are made of chestnut rather than the more usual oak. Chestnut is more resistant to attack by insects, and the roof here shows less damage than most medieval oak roofs.

Work on rebuilding the church began in 1454 and continued for over fifty years, funded by a variety of donors, many of whom are detailed in the "Black Book of Swaffham" compiled by the Rector John Botewright in the mid-fifteenth century.

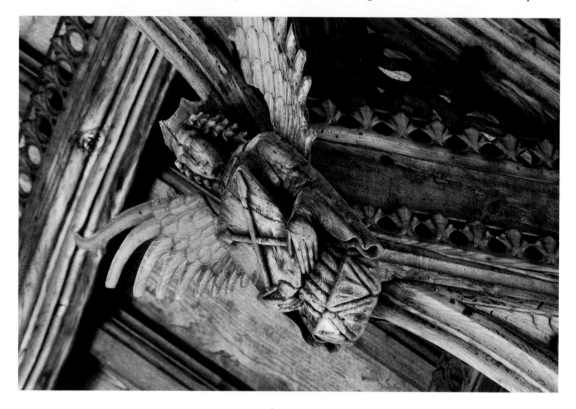

ABOVE:

A roof angel on the end of a hammer beam.

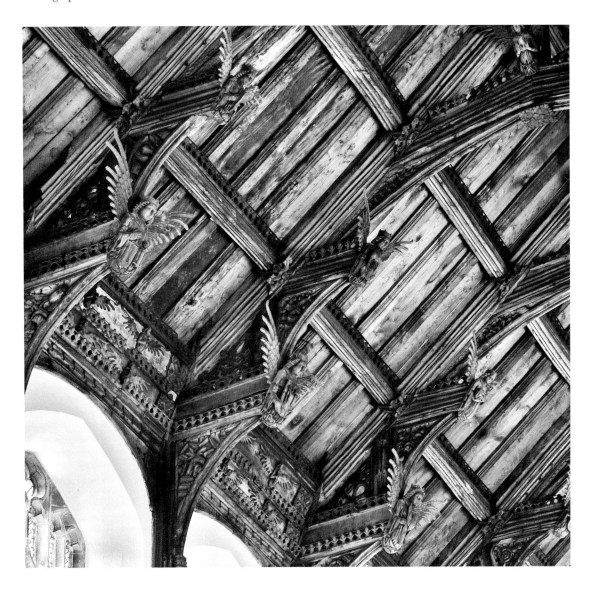

St Botolph, Trunch, Norfolk

OPPOSITE PAGE:

*An excellent single hammer beam roof with very fine carving in the spandrels,
likely to date from the mid-fifteenth century.*

It has been suggested that this roof inspired the Reverend Whitwell Elwin to build
the Victorian angel roof at Booton, since Elwin visited St Botolph as a child.

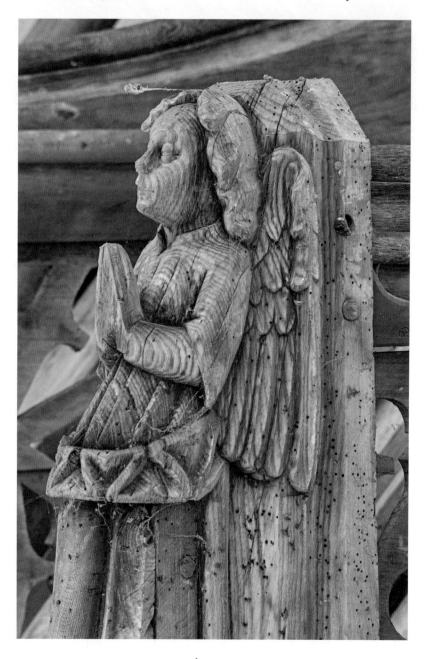

ABOVE:

A close-up of a roof angel set on the end of a hammer beam.

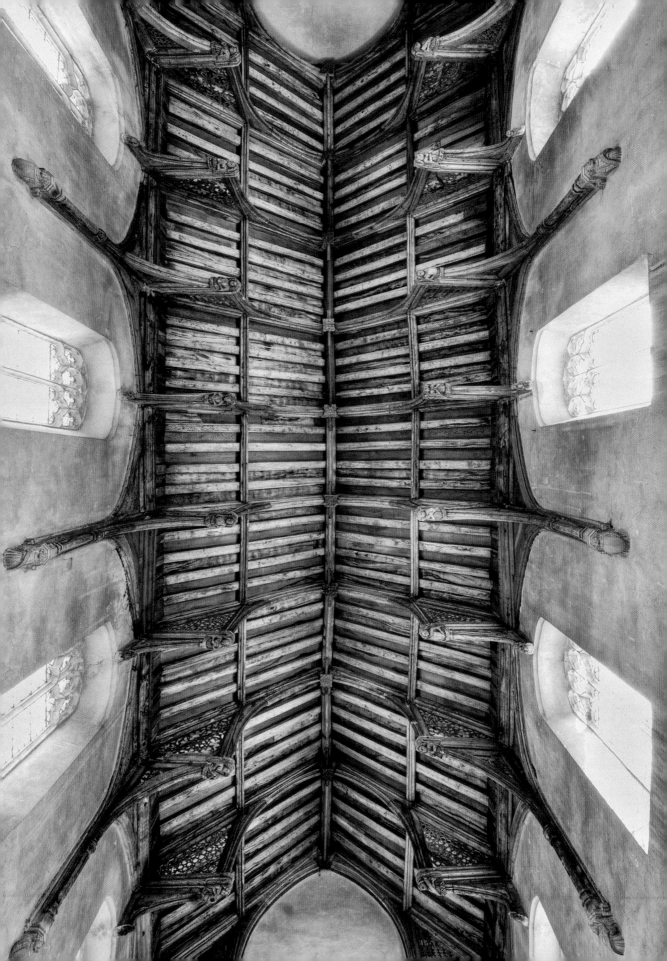

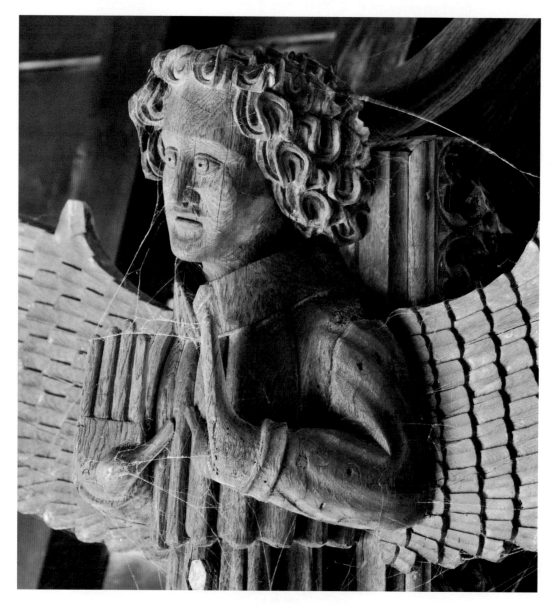

St Peter, Upwell, Norfolk

A roof angel extends its palms as if in blessing.

At St Peter in Upwell, in the west Norfolk fenland, the roof is one of tie beams alternating with hammer beams carved into angels. The roof structure is very similar to that at Lakenheath and Mildenhall in Suffolk. The angels at St Peter show marked similarity in carving style to those at St Mary, Mildenhall, and to some of the roof angels at St Nicholas, King's Lynn: deeply moulded intestine-like hair, eyes with heavily incised pupils and iris rings, and rather "wooden" drapery. They may all be

the work of the same carver. The roof of St Mary was made in the 1420s and that at St Nicholas c. 1405-10. St Peter's angel roof probably also dates from the first quarter of the fifteenth century.

A nineteenth gallery allows the visitor to get much closer to the roof angels than is normally the case (most such galleries were removed by the Victorians). St Peter in part provided the inspiration for the fictional fenland church of Fenchurch St Paul in Dorothy L. Sayers' thriller *The Nine Tailors* (Gollancz, 1934).

*Characterful secondary carvings from the roof: demons, demi-angels,
and the devouring of a sinner by a crocodile-like hell mouth.*

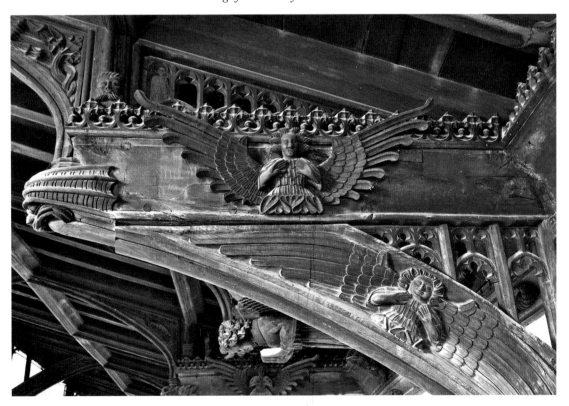

St Mary, West Walton, Norfolk

Opposite Page:

A roof in which arch-braced tie beams alternate with hammer beams,
with the hammers carved into angels, each of which carries a shield.

Images of Christ's Passion are shown on all the angels' shields, save two, which bear the arms of the Jermyn family of Suffolk, suggesting that they may have endowed or been major contributors towards the roof.

The roof seems to have been cut down to fit the church – note how the wall posts (the wooden verticals that project down the wall to transmit force lower down the building and so reduce outwards thrust) have been sawn off to fit the spaces between the intersections of the clerestory arches. The purlins (the horizontal beams connecting the rafters) have shifted alarmingly out of line.

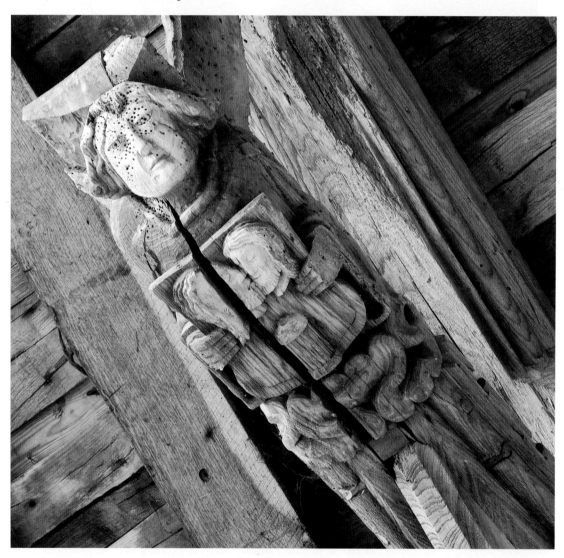

Above:

A hammer beam angel holds a shield
on which Judas betrays Christ with a kiss.

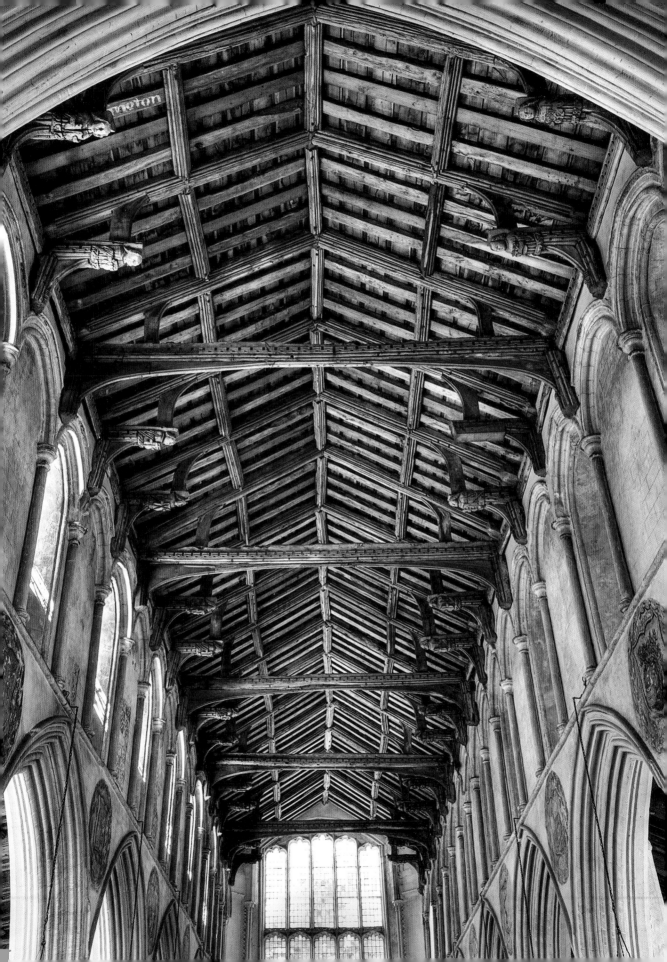

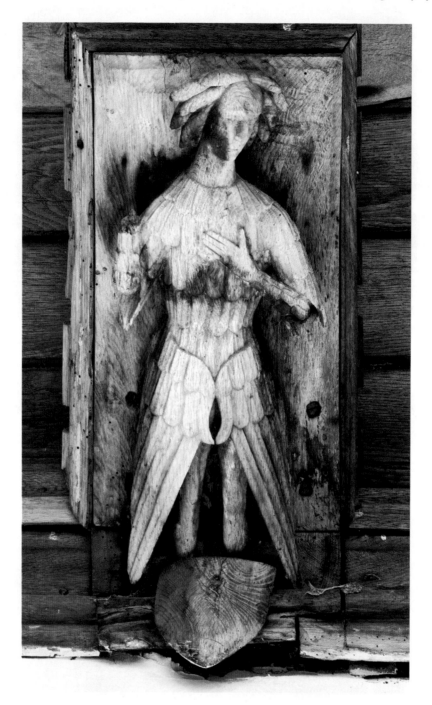

St Mary Magdalene, Wiggenhall St Mary Magdalene, Norfolk

*An angel clad in a tunic of feathers, terminating at the neck; the figure is,
unusually for a roof angel, shown with two pairs of wings.*

The angel roof at St Mary Magdalene alternates tie beams with short hammer beams, decorated with carved angels such as this. The carver renders the hair as pine-cone-like ringlets, and the figure has two pairs of wings, one furled over the lower body and the other draped, cloak-like, over the shoulders.

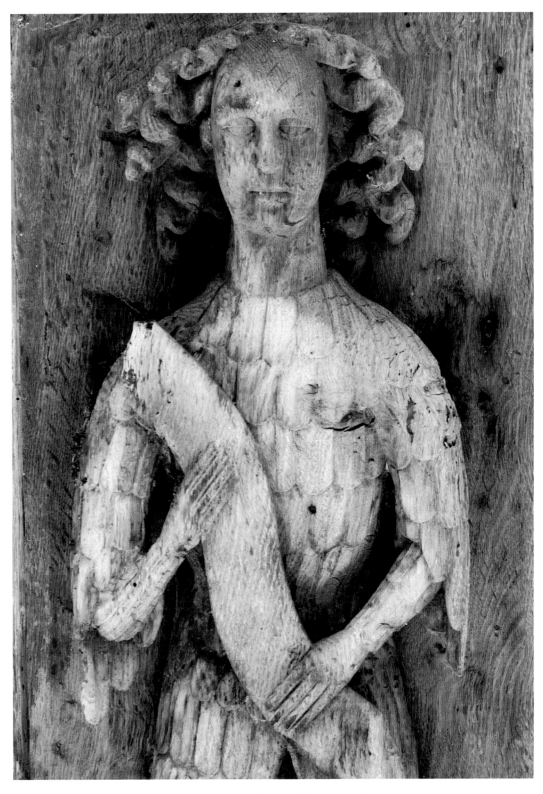

A delicately coiffed angel bears a scroll.
This figure was probably originally painted.

Wymondham Abbey, Wymondham, Norfolk

<small>OPPOSITE PAGE:</small>

*A section of the hammer beam roof,
showing the angel hammer beams more clearly.*

The roof is a wonderful single hammer beam construction, dating from c. 1445 – one of the finest angel roofs in Norfolk. It underwent restoration in the early twentieth century. The quality of carving, structural carpentry and the level of detail in this roof is outstanding; this would have been a very expensive construction. Note the exquisitely carved floral roof bosses.

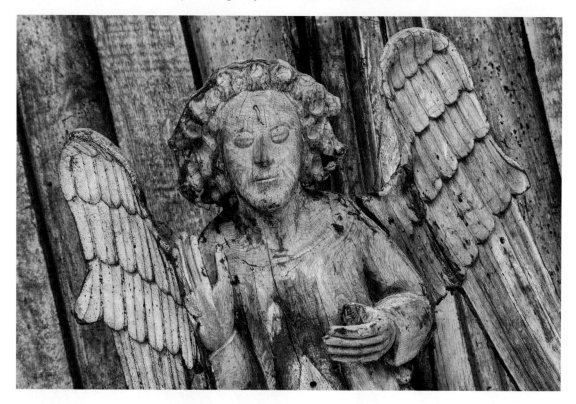

<small>ABOVE:</small>

A hammer beam angel raises its hand in blessing or salutation.

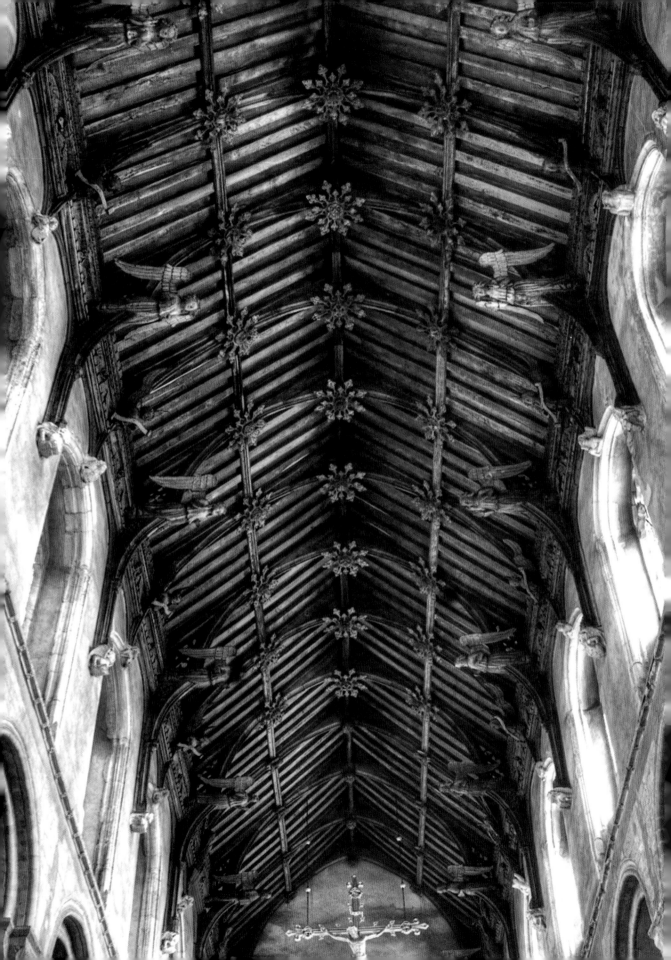

St Peter and St Paul, Bardwell, Suffolk

OPPOSITE PAGE:

*An angel carries a book bearing the date of
the roof's construction: MCCCCXXI – 1421.*

Unlike most angel roofs, St Peter and St Paul's can be precisely dated, as this angel (one of only four remaining out of an original twenty-six) carries a book bearing the date 1421 in Roman numerals, though the angel may have been repainted. The painting on the roof beams themselves is almost certainly original. The restrained colour palette of white, red, green and black is similar to that at Palgrave and Blythburgh.

St Peter and St Paul's other twenty-two angels have all been prised off the hammer beams, leaving them bare and exposing the tenons (projecting wooden tabs) which would have fitted into the mortices (corresponding slots) on the bodies of the sculptures. This destruction was the work of Puritan iconoclasts; a parish invoice survives, dated 7 February 1644, paying workmen for "pulling down the ymages" and "defacing pictures in glass and wood". The job lasted at least five days, and may have been done in anticipation of a visit from

William Dowsing, who was in the area at that time. Why did any angels survive? Perhaps because by the time twenty-two had been removed, Dowsing had left the area, and the parish decided to cut the destruction short to save money.

Given the date of 1421 shown in this photograph, the roof may well have been funded by Sir William de Bardwell (1367-1434), a prominent sponsor of the church. Bardwell fought in the French wars of the late fourteenth and early fifteenth centuries, and was with Henry V at the siege of Harfleur in 1415. He is depicted, in armour, in one of the windows on the north side of the nave (see p. xiv). The image has been slightly damaged and is patched with fragments of other glass, but it survived the religious vandalism of 1644. Heraldic and donor windows were generally not targeted in the Reformation or the Puritan destruction. This was a religious revolution; the social order was not to be challenged.

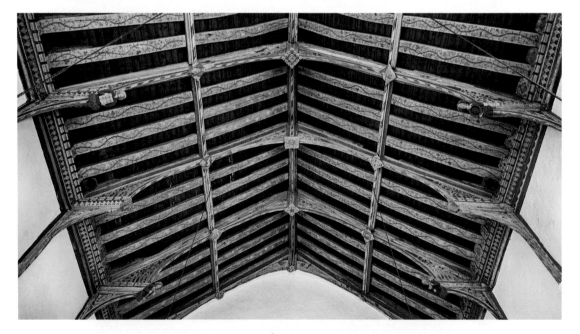

ABOVE:

*A section of the roof, showing the four angels that remain,
and the bare tenons from which angels were prised off in 1644.
The roof here is an arch brace and hammer beam construction.*

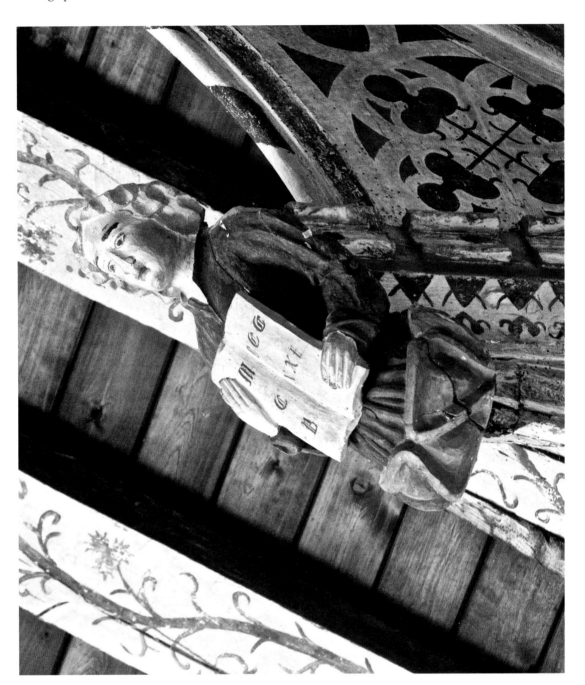

Holy Trinity, Blythburgh, Suffolk

Holy Trinity's cambered tie beam roof.

Famous as the "Cathedral of the Marshes", Holy Trinity was rebuilt between 1412 and 1480, while retaining an existing fourteenth-century tower. The drawn-out period of rebuilding reflects that fact that the village was not particularly prosperous by the fifteenth century. Expenditure was spread over many years, funded piecemeal by a series of local sponsors rather than by one or a handful of rich donors. The roof here is a cambered tie beam structure, richly painted along its whole length; the colour is almost certainly original. The restrained palette is similar to the painted roofs at Bardwell and Palgrave, also in Suffolk. Pairs of exquisitely carved and coloured angels adorn the intersection of the roof beams, facing east and west. They hold shields bearing the arms of the principal sponsors of the rebuilding.

On 9 April 1644, the Puritan iconoclast William Dowsing visited Holy Trinity as part of his commission to destroy religious imagery and Laudian "innovations" (such as altar rails and steps) in the eastern counties. He ordered "twenty cherubim to be taken down . . . and gave order to take down above 200 more pictures [i.e. stained glass images] . . . within eight days". Dowsing's journal records that he visited at least five other churches in the area on the same day.

Dowsing's destructive progress was often very hurried. He would arrive at a church, identify offending images and instruct that they be destroyed within a fixed period. If time allowed, he might oversee some limited, easy destruction then and there, before moving on to the next target. Sadly, most of Holy Trinity's medieval glass was destroyed, but Dowsing's orders to take down the roof angels were not followed. A comparison of the instructions detailed in his journal with what remains at many of the churches he visited shows that this was often the case. Once he had gone, churchwardens and parishioners chose not to follow his orders, either because the work was too arduous (perhaps particularly so with roof angels) or because they did not share his Puritan zeal.

Holy Trinity's angels show signs of shot damage, and it used to be thought that this had been inflicted during the Puritan iconoclasm. However, restoration works in 1974 revealed that the shot embedded in the angels was of a type not known before the eighteenth century, and the churchwardens' accounts for the period show that the shot damage was a result of attempts to clear flocks of jackdaws from the church.

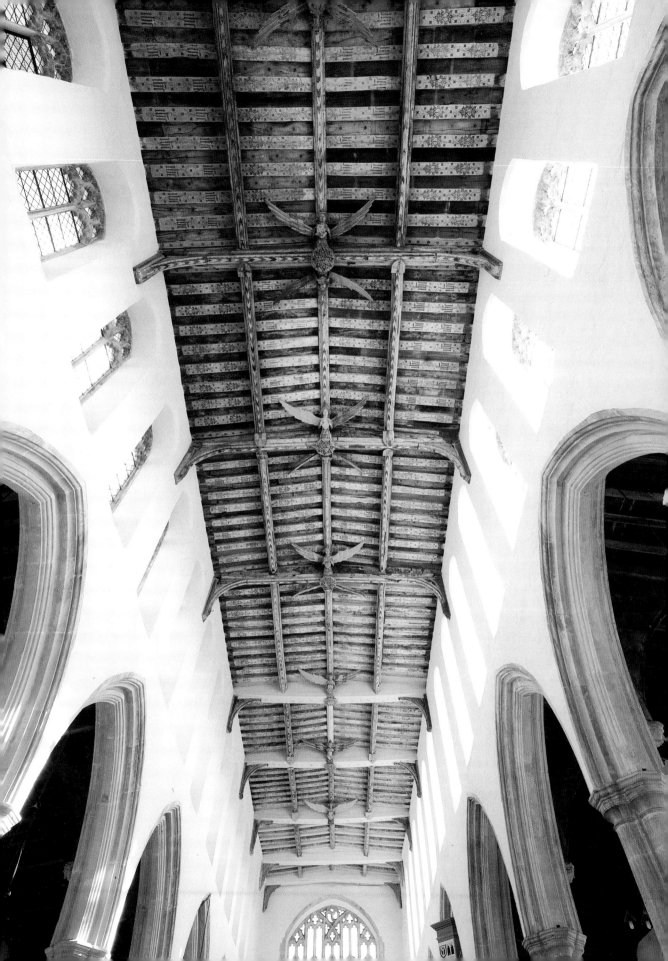

St Mary, Bury St Edmunds, Suffolk

*St Mary has one of the finest of all angel roofs; its eleven pairs of angels,
facing one another across the nave, are arrayed as if in procession towards the altar.*

One of the largest parish churches in England, St Mary was largely rebuilt in the fifteenth century, funded by donations from wealthy locals. The angel roof was endowed by John Baret, a wealthy and well-connected Bury cloth merchant. Baret died in 1467, leaving a fabulously detailed will, in which he referred to "all the work of the angels on loft which I have do made for a remembrance of me and my friends". The roof angels nearest the altar (repainted in the nineteenth century) bear his motto, "Grace Me Govern".

John Baret's cadaver tomb can be seen on the south side of the church. The main sculpture shows him as a withered corpse, while in a small panel on the front, he appears alive and finely robed, touchingly carrying the central word of his motto, "Me" (see photograph on p. xii).

In addition to his wealth and local influence, Baret was awarded a silver collar of SS by Henry VI, a badge of preferment granted for personal service to the Lancastrian regime. He married well, but not apparently happily; his wife, Elizabeth Drury, whose family were also rich clothiers, is accorded only one short sentence in his forty-page will. The marriage was childless, and the couple would seem by the time of the will to have lived apart.

This is one of the finest of all angel roofs. Hammer beams alternate with arch braces; the hammer beams are carved as recumbent angels, set in pairs, eleven on each side of the nave.

The angels seem to form a procession, vested for High Mass. Starting from the east end, nearest the altar, they run as follows: 1) the painted angels of the ceilure; 2) incense bearers, carrying incense boats and spoons; 3) thurifers, carrying censers; 4) taperers, carrying spiked candlesticks; 5) sub-deacons, bearing bibles; 6) chalice bearers; 7) clergy, wearing chasubles; 8) choirmasters, their hands raised as if conducting; 9) archangels, clad in suits of feathers; 10) young women, bearing crowns; 11) and finally, at the west end, crowned kings holding sceptres, one bearing a heart, the other a book.

Writing in the 1960s, J.B.L. Tolhurst plausibly suggested that the king angels represent Henry VI (there is some similarity between the figures here and portraits of the king), and that the young women, bearing but not wearing crowns, depict Margaret of Anjou, who was betrothed to Henry in 1444, married him in April 1445 and was then crowned queen consort in May of the same year. Tolhurst therefore believes that the angel roof was commissioned during the period between the betrothal and Margaret's coronation (1444-5) and that this is why the female figures carry, but do not yet wear, the crown.

Henry VI's marriage to Margaret of Anjou was brokered by William de la Pole, Earl, then Marquis and, finally, Duke of Suffolk. By the 1440s, de la Pole was the *eminence grise* behind the king, who was ill-suited to rule and suffered from periodic bouts of mental illness. The marriage of Henry and Margaret was a key part of William de la Pole's (ultimately unsuccessful) strategy to reach peace with the French, and so cling on to what little remained of Henry V's conquests in France.

In my view, the figures in the roof intentionally carry a double connotation. On one level, they depict the enthronement of the Blessed Virgin as Queen of Heaven (this is, after all, the Church of St Mary, and Baret's will shows his especial devotion to the Virgin), but they can also be read as an expression of Baret's support for William de la Pole's foreign policy and his political faction. De la Pole had a strong regional power base in Suffolk, and it seems very likely that he, rather than the ineffectual king, was behind the decision to award Baret his silver collar of SS for services rendered.

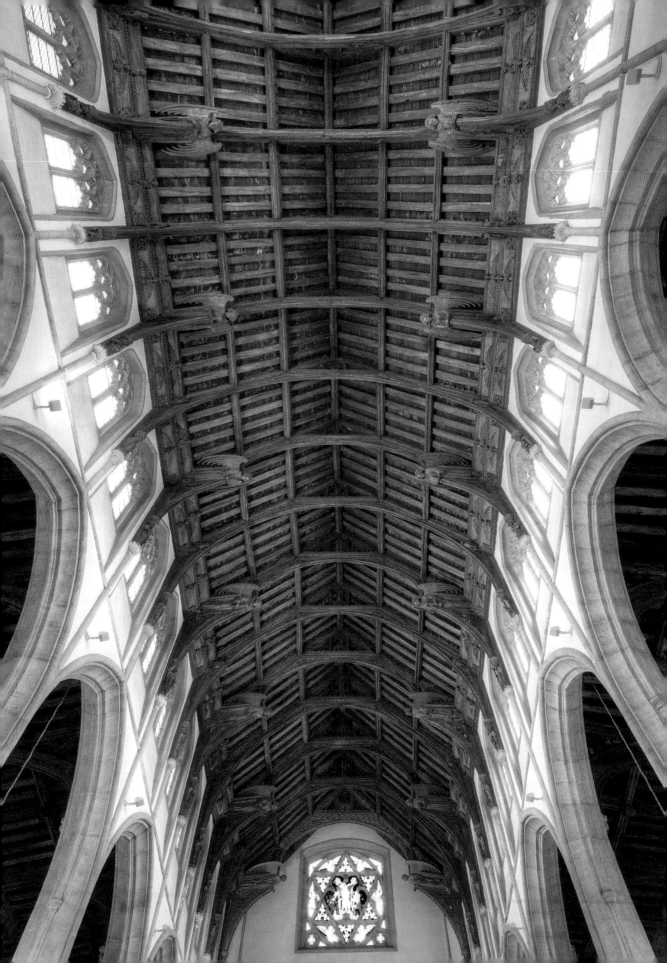

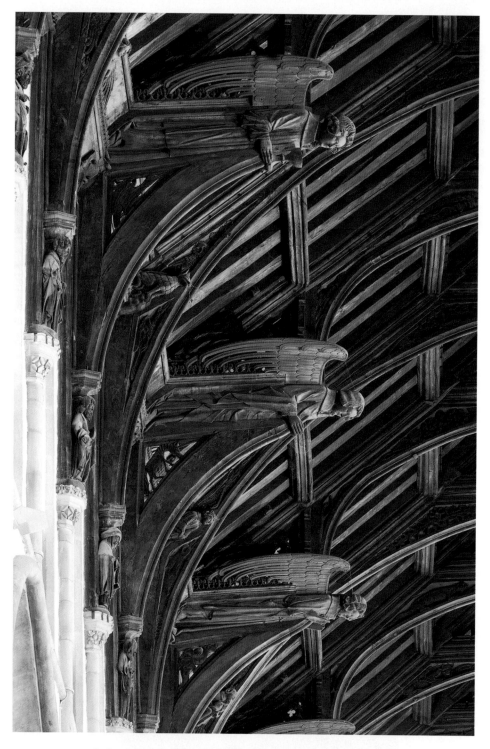

*A view along the nave roof at St Mary, showing the alternating
angel hammer beams and arch braces.*

The three angels shown are a chalice bearer, a celebrant and a choirmaster,
his hands raised as if conducting.

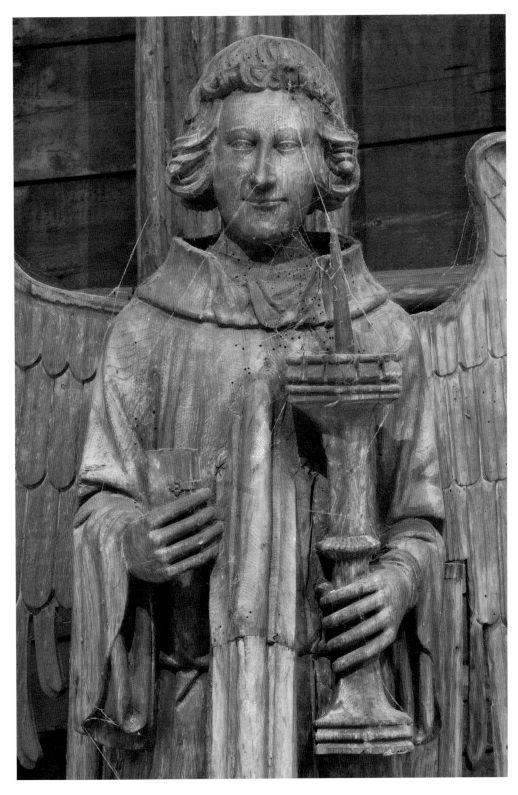

*An angel "taperer" at St Mary carries a spiked candlestick, and in his right hand
a small box, perhaps meant to contain a flint and steel for lighting candles.*

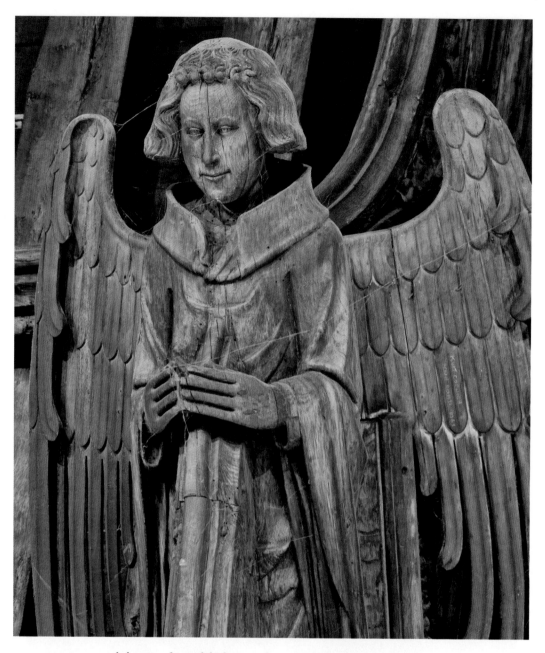

*A close-up of one of the hammer beam angels at St Mary, dressed as
a celebrant of the Mass, his hands joined in prayer.*

The wing on the right of the photograph bears a chalked graffito left by a workman from the restoration of the early 1960s: "K.W.J. Cornish, Perry Road, 1963".

The carving is of exceptional quality and is probably the work of craftsmen attached to Bury Abbey. John Baret had strong connections to the Abbey, which was itself a major economic power in the region, and would seem to have acted as a lay adviser to the abbot. The faces of the twenty-two angels in the roof are all strikingly real, and may be portraits of actual people, particularly since in his will Baret refers to the angels as "a remembrance of me and my friends". Amongst the angel figures are one with a slight squint, and another with a double chin.

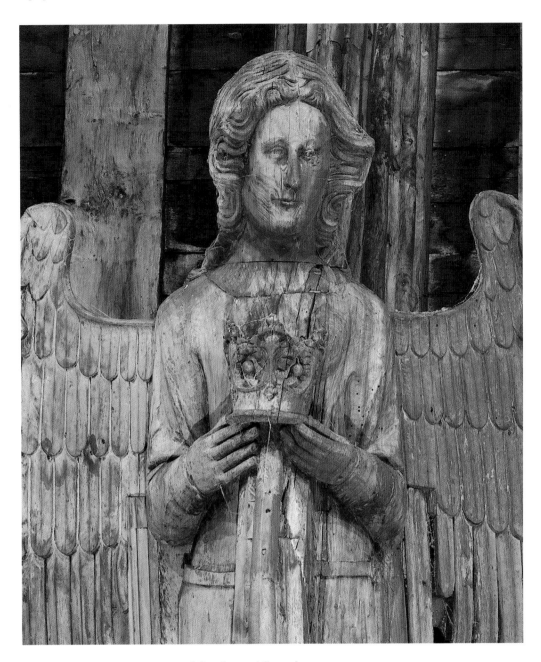

A female angel figure bears a crown.

Following J.B.L. Tolhurst's theory, Mortlock (in his *Guide to Suffolk Churches*) writes that she "could well represent Margaret of Anjou, betrothed to Henry VI in 1444 and crowned in May 1445" and adds, "it is tempting to suppose that the roof was finished in time for Henry to see it when he held his parliament in the [Bury] abbey refectory in February 1447."

The Bury Parliament of 1447 was momentous in the power politics of the time. On his arrival in the town, Humphrey, Duke of Gloucester, brother of the late King Henry V and the leading opponent of William de la Pole's policy of brokering a peace with the French, was placed under house arrest and died of a stroke. With Gloucester dead, de la Pole enjoyed untrammelled influence over Henry VI, until the failure of his policy in France led to de la Pole's own impeachment, exile and murder in 1450.

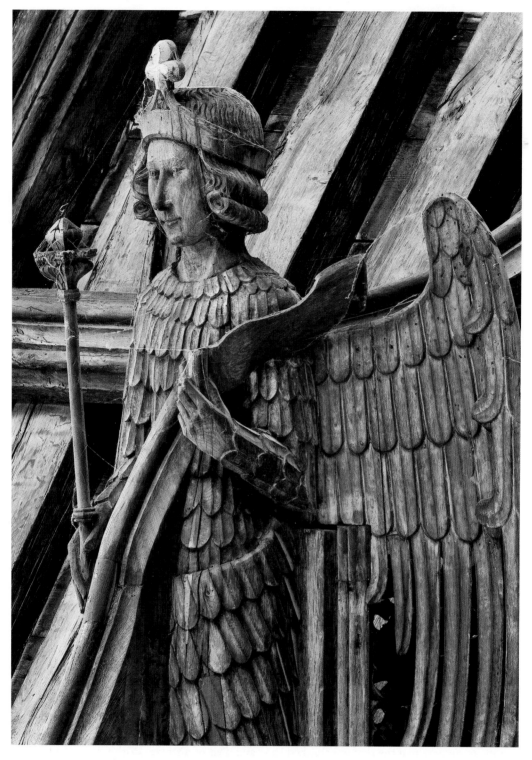

An archangel from the south side of the nave roof at St Mary.

He is clad in a suit of feathers, like an actor in a medieval pageant
or mystery play, and bears a wand and scroll.

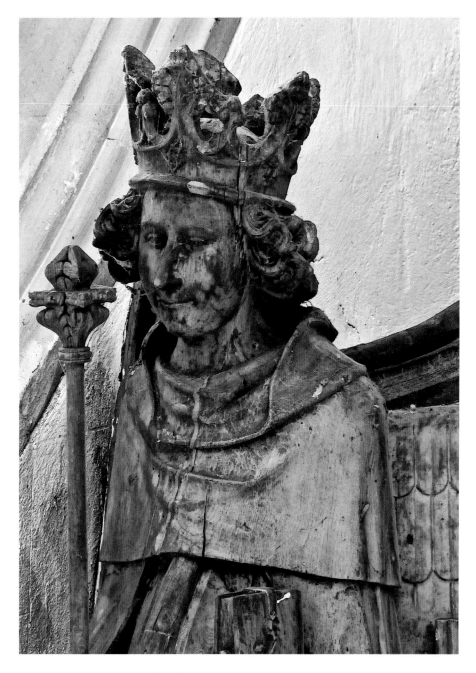

One of the pair of "king" angels from the west end of the roof at St Mary.

As throughout the roof, this is carving of breathtaking quality, probably executed by craftsmen attached to Bury Abbey; John Baret was, we know, a confidant of the Abbot. As discussed in "Heaven in the Rafters", the roof may well carry a double connotation, both symbolising the coronation of Mary as Queen of Heaven (in which case the crown bearing female figure is the Virgin, and the king figure Christ) and signalling Baret's political alignment with William de la Pole. On this reading, the female figure is Margaret of Anjou, and the "king" angel Henry VI. Margaret's betrothal and marriage to Henry was brokered by de la Pole with the aim of reaching peace with the French and safeguarding England's few remaining possessions in France. Ultimately, it failed.

St Andrew, Cotton, Suffolk

A superb false double hammer beam roof,
of similar design to that at Bacton nearby.

Hammer beams alternate with arch-braced trusses. The lower tier of hammers has no angels, but "pendant" hammer posts that project below the hammer beams and terminate in finials; the upper hammers are adorned with angels. In a bequest of 1471, a certain Thomas Cook left land to fund a new roof, dating the construction to the early 1470s. Note how the bay nearest the chancel arch is boarded, unlike the others. This section was the ceilure or "canopy of honour" and would have been richly decorated, reflecting its proximity to the altar.

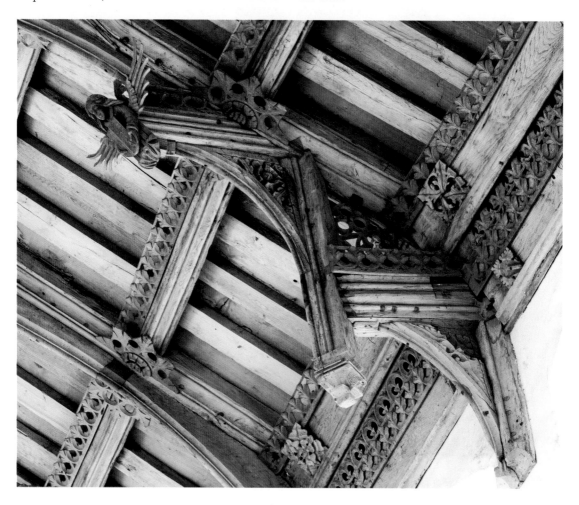

ABOVE:

A close-up of the false double hammer beam
structure at St Andrew.

The hammer post projects below the lower hammer beam, forming a "pendant". The upper hammer beam is finished with an angel (the carving is a replacement), but has no hammer post running upwards to the rafter above it, making this a so-called "false" double hammer beam roof. In practice, the elaborately carved arch brace below the upper hammer beam helps to convey force lower down the structure.

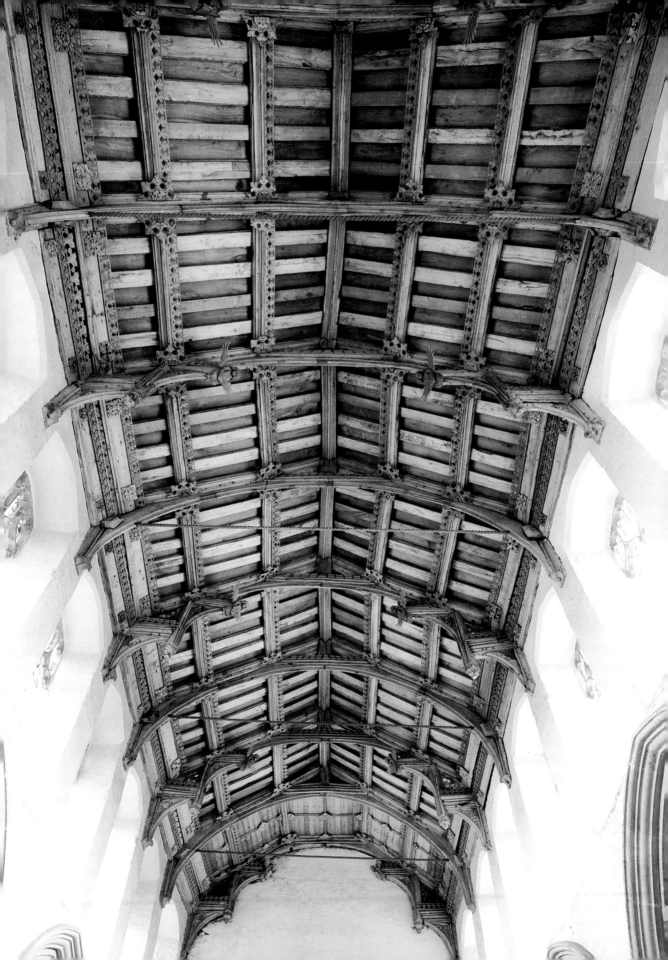

St Mary, Earl Stonham, Suffolk

<small>OPPOSITE PAGE:</small>

A magnificently ornate single hammer beam roof,
of ten bays, which alternates hammer beam angels
with intricately carved pendant hammer posts.

Demi-angels line the wall plates, and there is very fine carving to the spandrels of the arch braces of the hammer beams and collar beams. The hammer beam angels carry shields, on some of which the instruments of the Passion are still visible. All have had their heads neatly sawn off, probably in the Puritan image destruction of the 1640s. William Dowsing does not record visiting Earl Stonham in his journal; the angel decapitation may have been the work of the parish authorities or Parliamentarian soldiers.

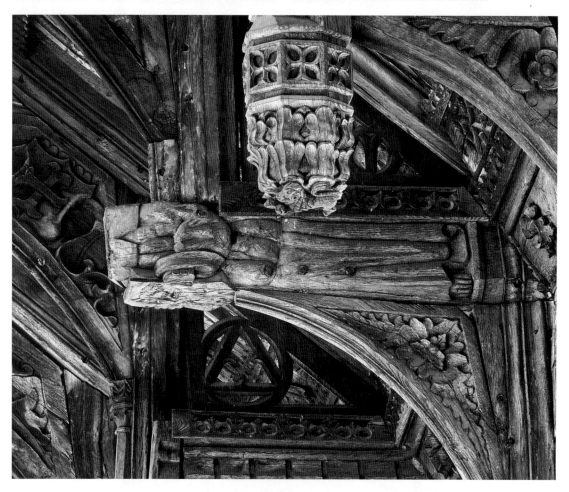

<small>ABOVE:</small>

A decapitated angel.

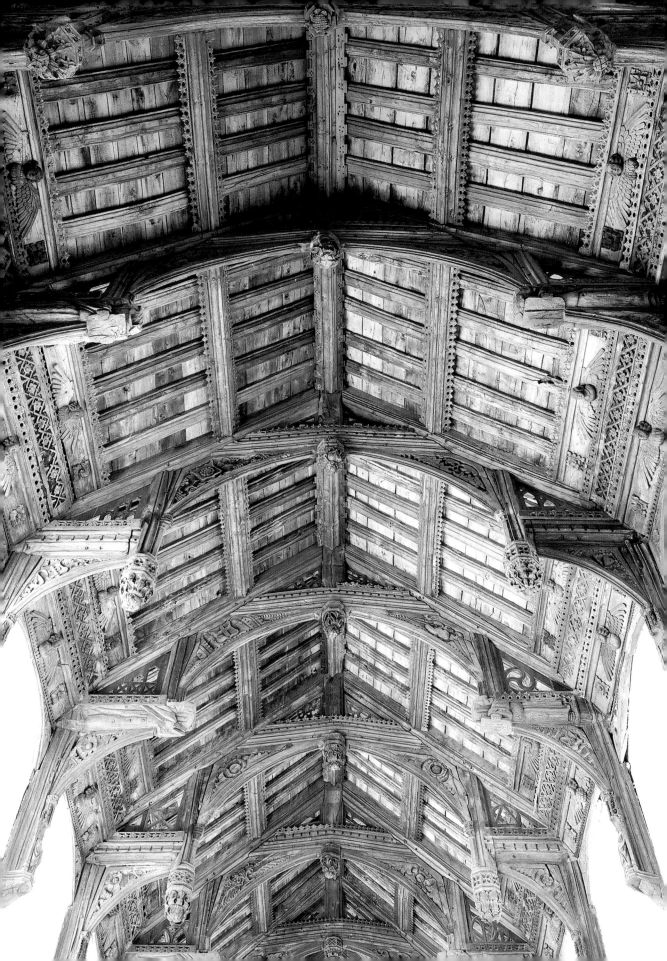

All Saints, Hawstead, Suffolk

All Saints' nave roof,
which was heavy-handedly restored in 1858.

The All Saints angels' heads and wings are mostly Victorian replacements; the bodies are original. The roof alternates arch-braced collars with full-body angel hammer beams, and is generally said to date from the early sixteenth century.

The church is filled with monuments to the wealthy Drury family, lords of the manor at Hawstead in the sixteenth century, and they are the likely donors of the angel roof.

In *Suffolk Medieval Church Roof Carvings*, Birkin Haward highlighted stylistic similarities between the roof structure and carving of All Saints and the much earlier angel roof at St Mary in Bury St Edmunds, which dates from the 1440s.

The donor of the angel roof at St Mary, John Baret, was married to Elizabeth Drury, daughter of Sir Roger Drury. Like Baret, the Drury family were, at this time, wealthy clothiers. The design of All Saints' roof – which, with its full-length hammer beam angels, seems slightly anachronistic for the sixteenth century – may well have been inspired by Baret's mid-fifteenth-century roof at St Mary.

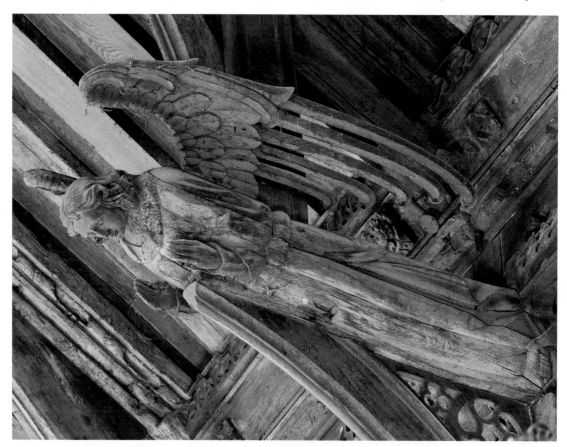

ABOVE:

A full-length hammer beam angel whose wings,
head and probably hands have been restored.

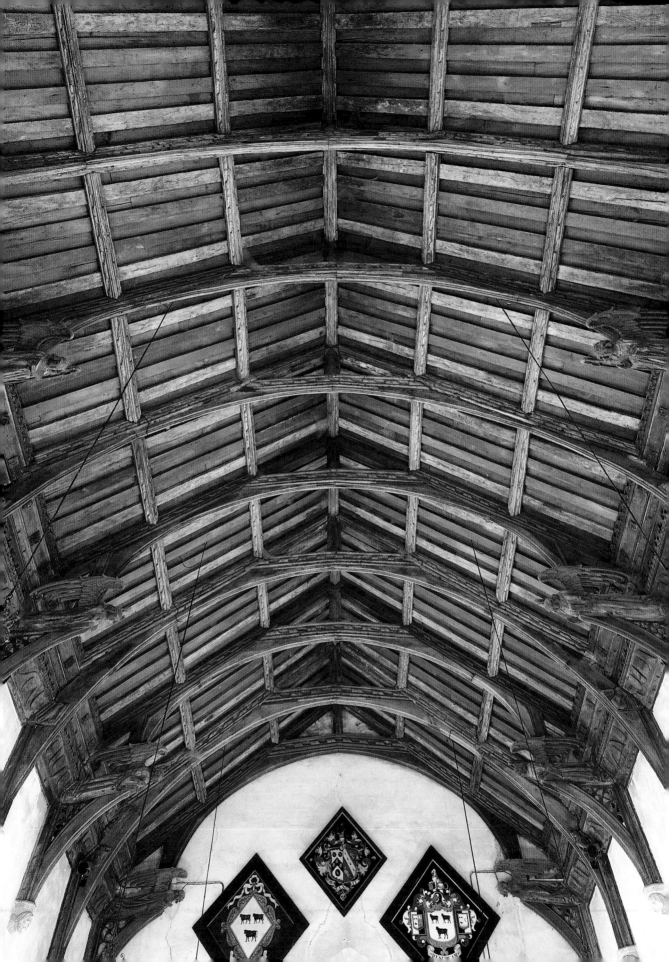

St Mary, Mildenhall, Suffolk

OPPOSITE PAGE:

*An alternating arch brace and hammer beam roof,
which dates from the 1420s.*

The roof here was probably endowed by Sir Henry Barton, who came from Mildenhall and was Lord Mayor of London in 1416 and 1428. Barton was a contemporary of Sir Richard Whittington, immortalized – inaccurately – in pantomime.

As Sheriff of London in 1405, Henry Barton introduced street lighting to the city, ordering "lanthorns" to be put out in the winter months. He has a cenotaph at St Mary, but was actually buried in old St Paul in London, which was later destroyed in the Great Fire of 1666.

The carpentry and carving in the nave roof are of a very high standard, while in the north aisle the spandrels have some of the finest medieval carving in England; intricately depicted scenes include a hunt, the Annunciation and the angel telling the shepherds of Christ's birth.

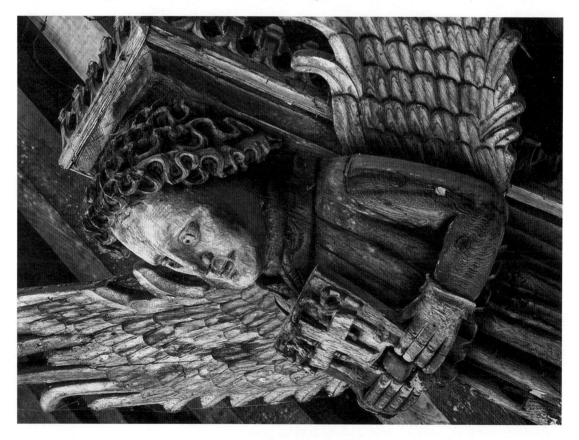

ABOVE:

*A close-up of one of the angels in the nave roof at
St Mary, Mildenhall, dating from the 1420s.*

The figure appears to be the work of the same man who carved some of the roof angels at St Nicholas, King's Lynn (c. 1405-10). The intestine-like rendering of the hair, the eyes with their heavily incised pupils and iris rings, the "mandarin collar" of the tunic and the rather static drapery are all characteristic of his hand.

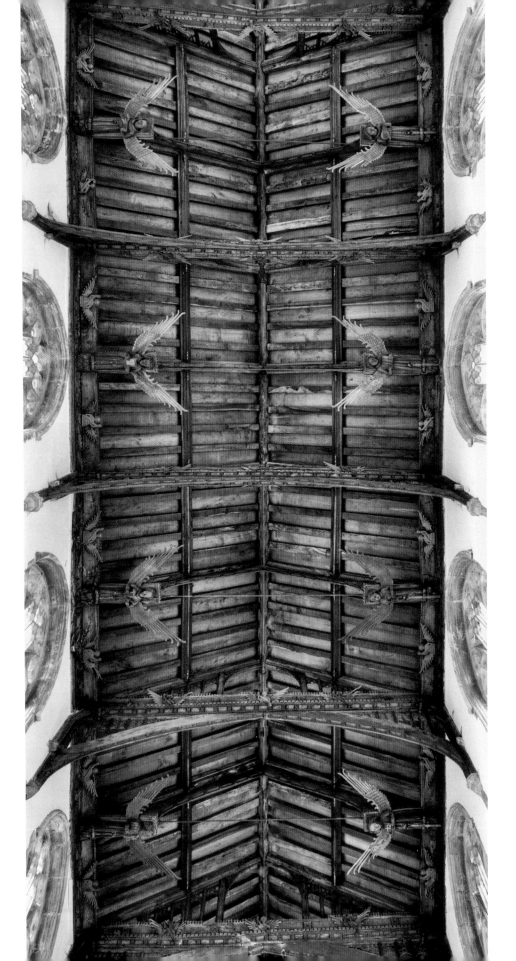

St John the Baptist, Needham Market, Suffolk

OPPOSITE PAGE:

*The angel roof at St John the Baptist, Needham Market, which is unique in its structure
and audacity; this is technically a single hammer beam roof, but of
an extraordinary design, found nowhere else.*

St John the Baptist, Needham Market, was built in the late fifteenth century, under the patronage of Bishop William Grey of Ely. The jumbled and ungainly exterior of the church today gives no hint of the wonders within. In *The Buildings of England*, Pevsner wrote that the nave roof mirrors the structure of an entire church, with nave, aisles and clerestory seemingly floating in the air. Both the hammer beams (partly concealed by the timber fascia) and the hammer posts are exceptionally long, braced together with tie beams just below the level of the clerestory and along the length of the nave. The whole thing gives the impression of an inverted ship's hull, hovering above the visitor. The probable influence of East Anglian shipwrights on roof development in the region has been noted in the opening essay, "Heaven in the Rafters"; this is the most ship-like of all angel roofs, though much of it is now Victorian restoration, rather than medieval original. Until 1880, the nave roof was hidden by a plaster ceiling. When uncovered, it was found that many of the hammer beams had been sawn off, necessitating extensive reconstruction. Consequently, all the lower timbers are nineteenth-century replacements; the windows on the north side of the clerestory were also put in at this time. The angels on the ends of the hammer beams were added in 1892, in memory of Major William Dods.

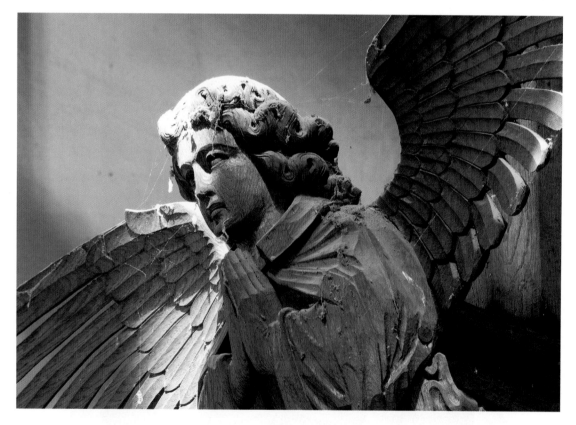

ABOVE:

*A roof angel with its hands joined in prayer,
illuminated by a ray of sunlight.*

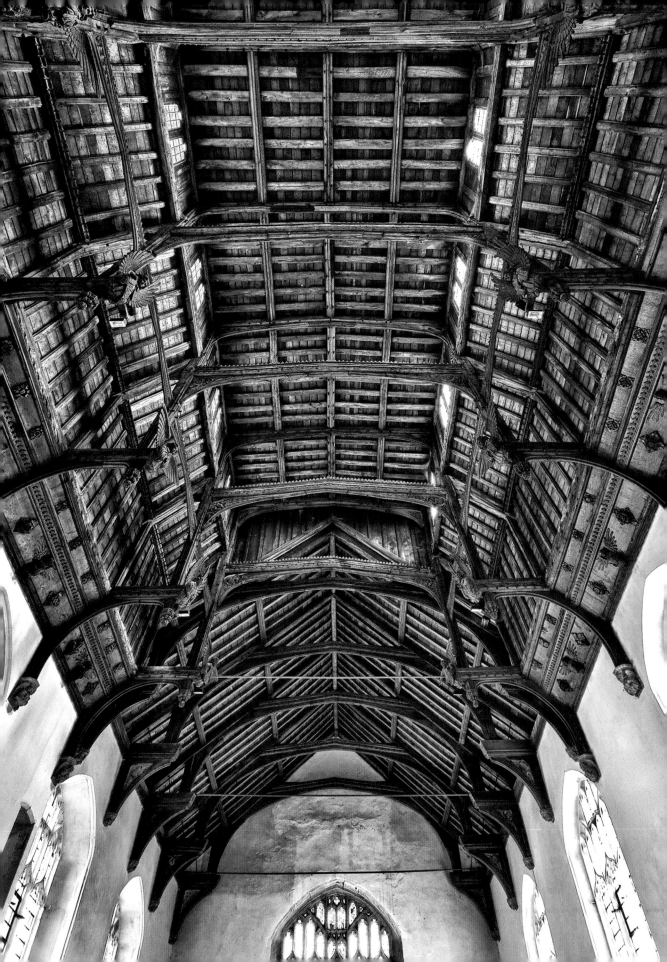

St Mary, Woolpit, Suffolk

OPPOSITE PAGE:

*A breathtaking false double hammer beam roof – described as "false" because the
upper tier of hammers is purely decorative, rather than load-bearing
(it has no vertical hammer posts to connect it to the rafters).*

Mortlock suggests that it dates from 1440-50, while Birkin Haward places it later, estimating 1455-60. The ends of the hammer beams are adorned by sixty-six angels (with over sixty more in the aisles). They are mostly (perhaps all) not original, but were restored in 1862 by the master carver Henry Ringham of Ipswich (1806-66). Ringham worked on many other churches in the area, and did well enough to build himself a rather grand mock-Tudor house (the Gothic House) in Ipswich before going bust.

Ringham's replacement of so many angels here suggests that they had been destroyed by iconoclasts, but probably not by William Dowsing. His deputy visited the church on 29 February 1644 and Dowsing made the following entry in his journal: "My Deputy. 80 Superstitious pictures; some he brake down, and the rest he gave order to take down; and three crosses to be taken down in 20 days – 6s. 8d." There is no mention of St Mary's roof angels, which suggests that they had already gone, probably removed by the locals beforehand.

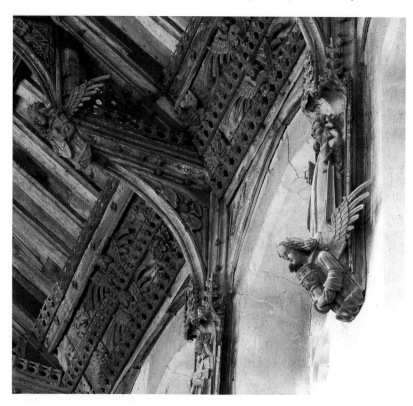

ABOVE:

*A close-up showing original medieval carvings alongside
Henry Ringham's beautifully carved replacement angels.*

The hammer beams and other timber are original. The elaborately carved decorative edging along the top of the hammer beam was called "traylle" by medieval carpenters. The roof has begun to spread outwards. Modern steel angle braces (just visible above the hammer beams in the mid-left and bottom left of the picture) have been fitted to counteract this.

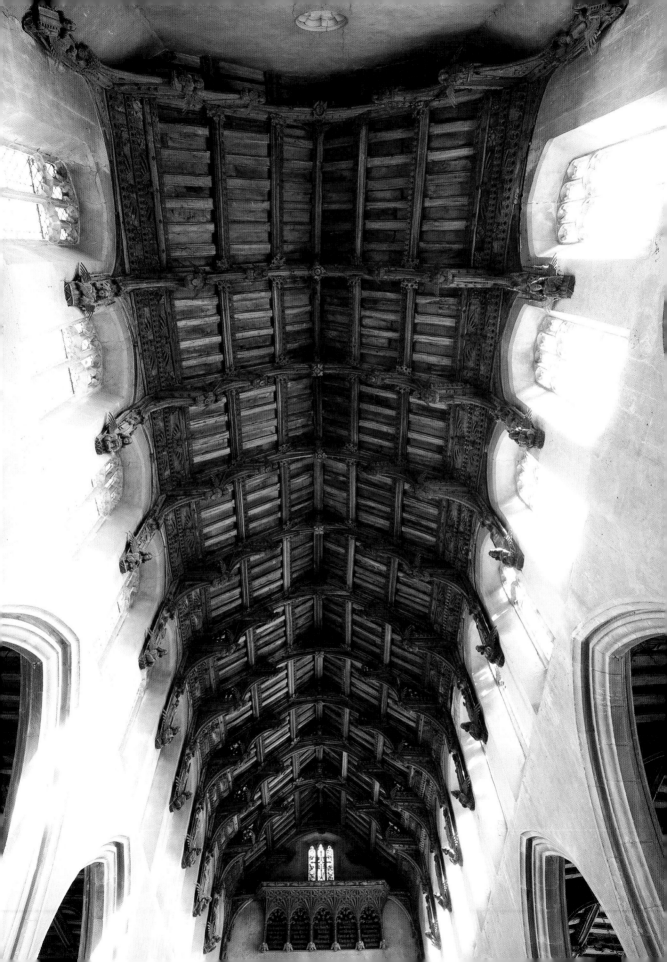

All Saints, Ellington, Cambridgeshire

OPPOSITE PAGE:

*A handsome nave roof of four bays, dating from the late fifteenth century,
a period when the church was under the patronage of Ramsey Abbey.*

The principal rafters alternate arch braces (with carved apostle figures at the foot of
the wall posts) with full-size angels set at the apexes of the clerestory windows.

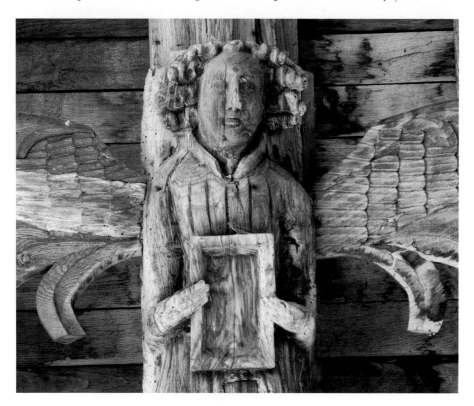

ABOVE:

*One of the angels at All Saints carries the nails of the Passion,
another (shown here) a book.*

The angels in the nave are undamaged, though their wings appear to have been replaced,
probably during the restoration of 1907-8. Angels in the aisle roofs have been
less lucky; several have had their faces hacked flat by iconoclasts.

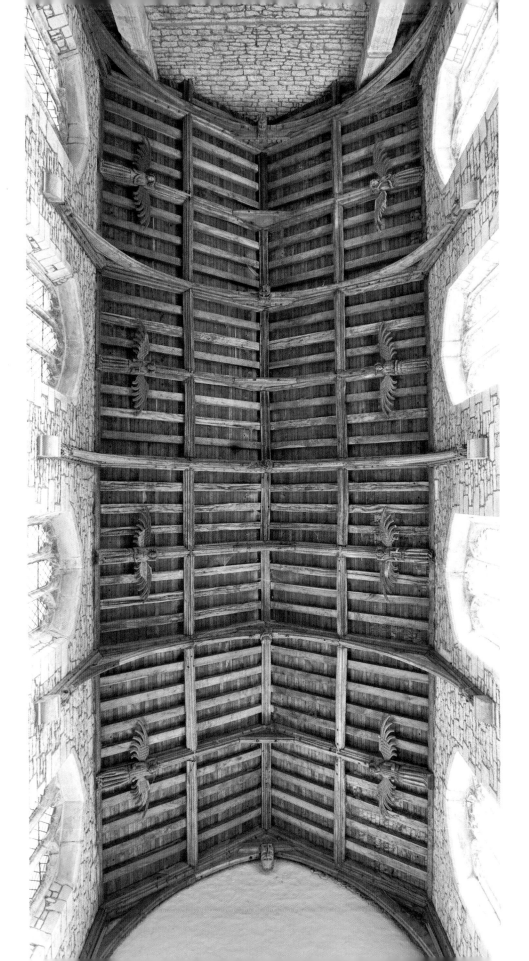

St Andrew, Isleham, Cambridgeshire

OPPOSITE PAGE:

*A section of St Andrew's nave roof,
showing three of its five bays.*

Tie beams, supported by arch braces and topped with queen posts and spandrels, alternate with angels on hammer beams. The whole roof features ten full-size angels bearing the instruments of the Passion.

This is one of the finest angel roofs in Cambridgeshire, illuminated by one of the finest clerestories in the county. Along the wall plate (visible on either side of this photograph) runs a carved inscription, giving the date of the roof's construction, and the name of its donor:

Pray for the good prosperite of Crystofor Peyton and Elizabeth his wife and for the soul of Thomas Peyton squire and Margaret his wife fader and moder of the said Crystofor Peyton and for the souls of all the awncestre of the said Crystofor Peyton qwych

dyd mak this rofe in the year of our lord MCCCCLXXXXV [1495] being the tenth year of King Henry the Seventh.

Christopher Peyton's father Thomas acquired the manor of Isleham through his first marriage to Margaret Bernard. On her death he remarried, to another Margaret, daughter of Sir Hugh Francis of Wickhambrook in Suffolk. Christopher was a product of this second marriage; he inherited "great possessions" in Suffolk and became sheriff of Huntingdonshire and Cambridgeshire, but died childless, in 1507. The family line continued through his brother and half-siblings. The church contains grandiose tombs to these later generations, but none of them outshine Christopher Peyton's roof.

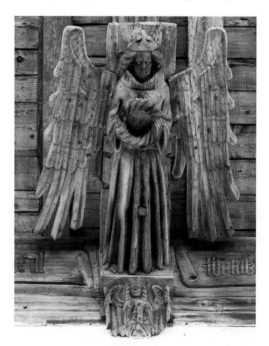

ABOVE:

*An angel from the roof of St Andrew bears the crown of thorns
of Christ's Passion, again rendered as a padded torque.*

Part of the inscription that dates the roof to 1495 can be seen on either side of the figure, and at its feet, another diminutive angel on a carved plaque.

Beautifully carved half-angels are also positioned at the ends of the wall posts that run down from the arch braces in the roof.

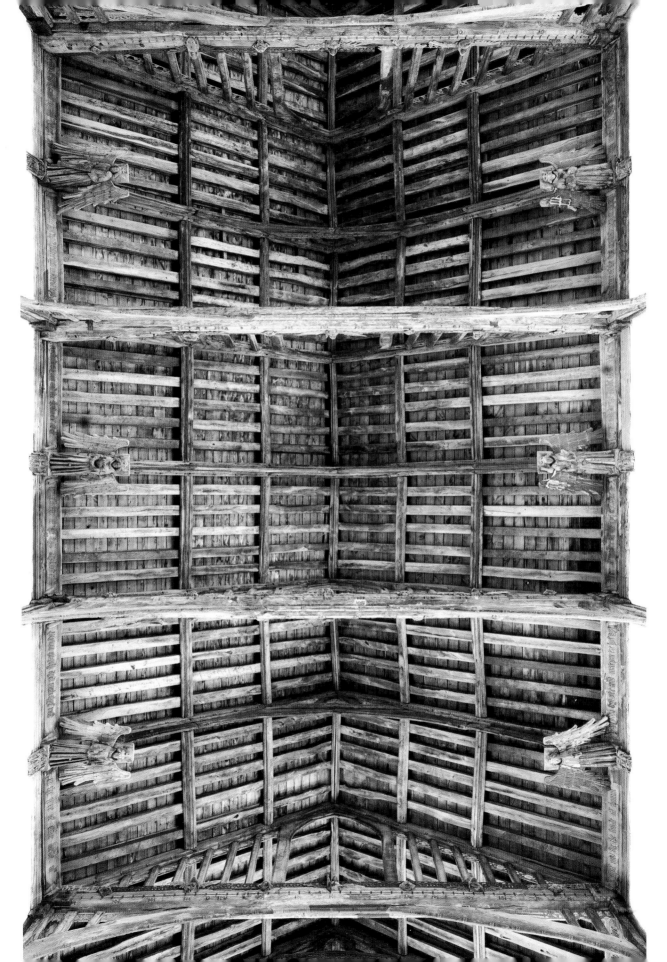

St Andrew, Kimbolton, Cambridgeshire

OPPOSITE PAGE:

An angel, now wingless, carries the crown of thorns,
a symbol of Christ's Passion.

The nave roof of St Andrew, Kimbolton, has no angels, but the rafters of the roofs in the north and south aisles, dating from c. 1500, are adorned with a variety of carved figures, including a winged St Michael vanquishing a dragon, and angels carrying the symbols of the Passion. The roofs were much restored in 1931, and some of the figures have been crudely repainted, while others are bare wood. Here an angel carries the crown of thorns. The crown is rendered as a padded torque, following the costuming conventions of medieval religious dramas (see "Heaven in the Rafters"). The holes in which the wooden "thorns" were once set are clearly visible.

ABOVE:

A painted demi-angel on the wall plate at Kimbolton bears a scroll with
the first words of the exhortation "'Surgite mortui [venite ad iudicium]",
meaning "Arise you dead [and come to Judgement]".

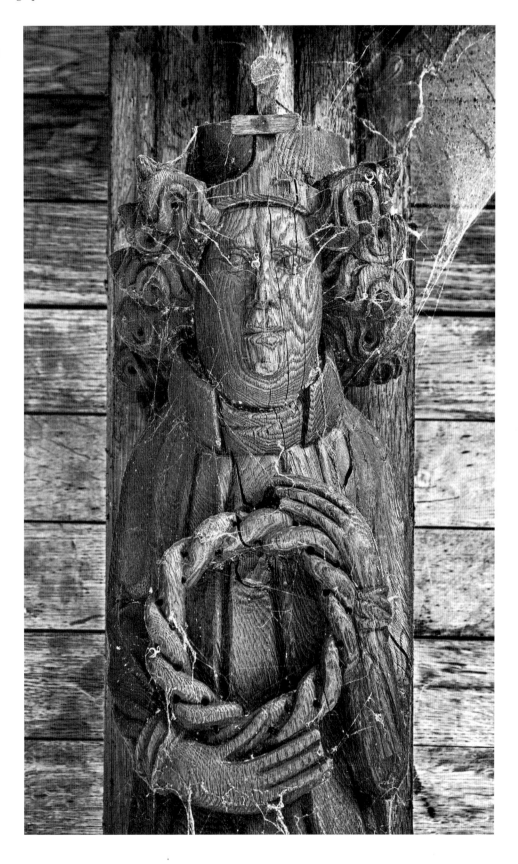

St Wendreda, March, Cambridgeshire

Opposite Page:

*The roof at St Wendreda is a false double hammer beam roof ("false" because the upper
tier of hammers is not connected to the rafters by hammer posts), ornamented
with 118 fluttering angels on its various surfaces, in addition to
carvings of saints and apostles.*

Sir John Betjeman remarked that the angel roof here was "worth cycling forty miles into a headwind" to see. He had a point. Along with Knapton, Swaffham and Woolpit, this is one of the four great massed angel roofs in East Anglia.

The structural pattern is very similar to the group of false double hammer beam roofs found in and around Bacton in Suffolk, and for this reason, Birkin Haward suggested that the roof at St Wendreda may have been made in a workshop there and then transported to March for assembly.

The roof is generally thought to have been erected in the late fifteenth century, funded by one William Dredeman (d. 1503) who has a memorial brass in the church, though some suggest a date between 1523 and 1526. Most of the angels' wings appear to be replacements, as do some of the angels themselves.

The church in March is the only one in the country dedicated to St Wendreda, an Anglo-Saxon princess revered for healing the sick with water from a holy well.

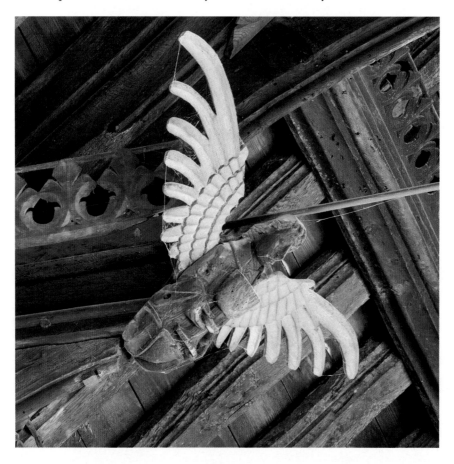

Above:

*An angel on the end of a hammer beam bearing a chalice.
The wings have been replaced.*

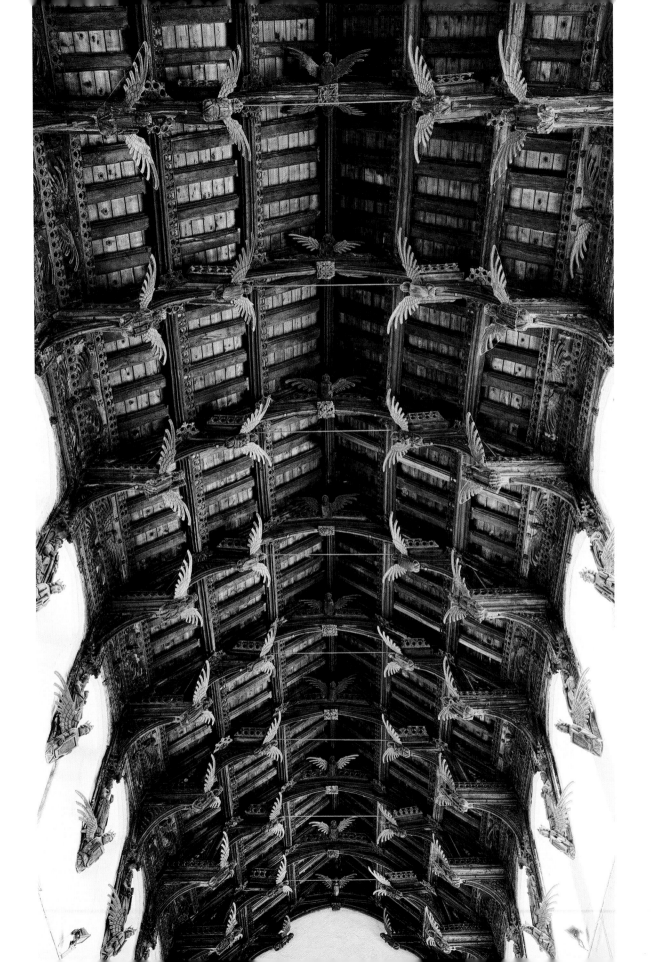

Appendix 1

Maps and Gazetteer:
Norfolk, Suffolk and Cambridgeshire

These lists include churches where the angels have been entirely removed.
*Locations with surviving angel roofs of particular quality are denoted in **bold.***

Norfolk

Banningham (St Botolph)
Barney (St Mary)
Blakeney (St Nicholas)
Burlingham (St Andrew)
Carbrooke (St Peter and St Paul)
Cawston (St Agnes)
Downham Market (St Edmund)
Emneth (St Edmund)
Fincham (St Martin)
Gissing (St Mary)
Glandford (St Martin)
Great Witchingham (St Mary)
Harpley (St Lawrence)
Hockwold (St Peter)
Holme Hale (St Andrew)
King's Lynn (St Nicholas)
Knapton (St Peter and St Paul)
Marsham (All Saints)
Mattishall (All Saints)
Methwold (St George)
Necton (All Saints)

North Creake (St Mary the Virgin)
Northwold (St Andrew)
Norwich (St Giles, St Mary Coslany, St Michael at Plea, **St Peter Hungate, St Peter Mancroft**)
Outwell (St Clement)
Oxburgh (St Mary)
Ringland (St Peter)
Salle (St Peter and St Paul)
South Creake (St Mary)
Sparham (St Mary)
Swaffham (St Peter and St Paul)
Swainsthorpe (St Peter)
Tilney (All Saints)
Trunch (St Botolph)
Upwell (St Peter)
Walsoken (All Saints)
West Lynn (St Peter)
West Walton (St Mary)
Wiggenhall (St Mary Magdalene)
Wymondham (The Abbey)

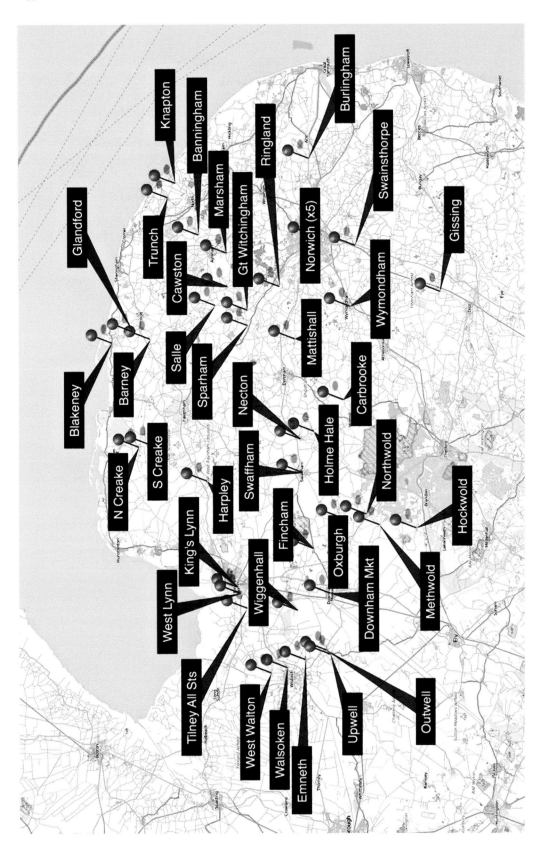

Suffolk

Bacton (St Mary)
Badingham (St John the Baptist)
Badwell Ash (St Mary)
Bardwell (St Peter and St Paul)
Bildeston (St Mary)
Blythburgh (Holy Trinity)
Bramford (St Mary)
Bredfield (St Andrew)
Bury St Edmunds (St Mary)
Coddenham (St Mary)
Cotton (St Andrew)
Earl Soham (St Mary)
Earl Stonham (St Mary)
Framsden (St Mary)
Gislingham (St Mary)
Great Barton (Holy Innocents)
Great Glemham (All Saints)
Grundisburgh (St Mary)
Haughley (St Mary)
Hawstead (All Saints)
Helmingham (St Mary)
Hopton (All Saints)
Ipswich (St Mary at Quay)
Ixworth (St Mary)
Kersey (St Mary)

Kesgrave (All Saints)
Lakenheath (St Mary)
Stonham Parva (St Mary)
Little Whelnetham (St Mary Magdalene)
Mildenhall (St Mary)
Needham Market (St John the Baptist)
Otley (St Mary)
Palgrave (St Peter)
Rattlesden (St Nicholas)
Rougham (St Mary)
Shotley (St Mary)
Sibton (St Peter)
Southcove (St Lawrence)
Southwold (St Edmund)
Tattingstone (St Mary)
Thornham Magna (St Mary Magdalene)
Tostock (St Andrew)
Ufford (Assumption of the Virgin)
Walsham-le-Willows (St Mary)
Wangford (St Peter and St Paul)
Westerfield (St Mary Magdalene)
Wetherden (St Mary)
Woolpit (St Mary)
Worlingworth (St Mary)

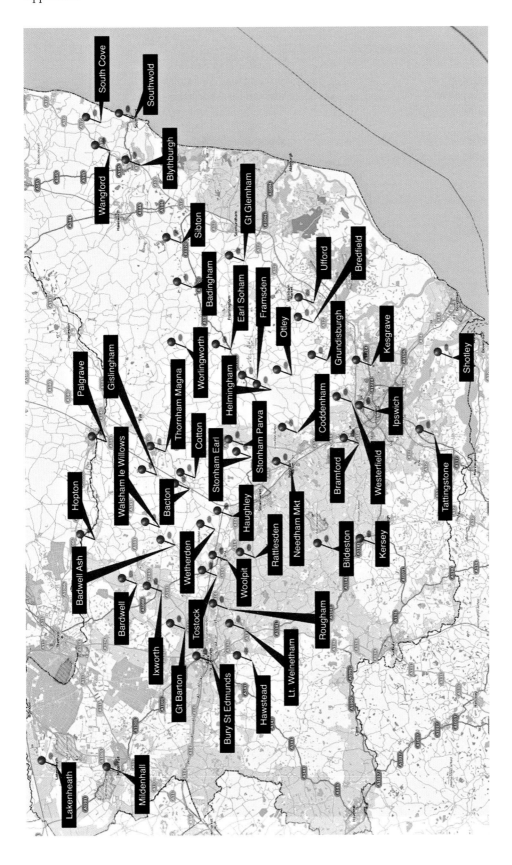

Cambridgeshire

Alconbury (St Peter and St Paul)
Buckden (St Mary)
Cambridge (Holy Sepulchre)
Castor (St Kyneburgha)
Comberton (St Mary)
Doddington (St Mary)
Ellington (All Saints)
Elm (All Saints)
Ely (Cathedral)
Fordham (St Peter and St Mary Magdalene)
Great Gransden (St Bartholomew)
Great Shelford (St Mary)

Hamerton (All Saints)
Huntingdon (All Saints)
Isleham (St Andrew)
Kimbolton (St Andrew)
Landbeach (All Saints)
Madingley (St Mary Magdalene)
March (St Wendreda)
Offord Cluny (All Saints)
Soham (St Andrew)
St Neots (St Mary)
Tilbrook (All Saints)
Willingham (St Mary and All Saints)

Appendix 2
Examples of East Anglian Roof Types

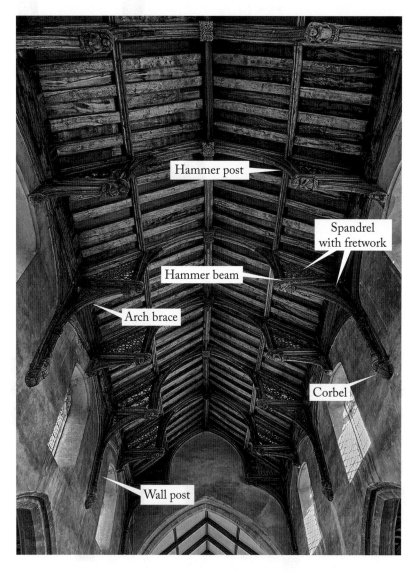

Hammer post

Spandrel with fretwork

Hammer beam

Arch brace

Corbel

Wall post

Single hammer beam roof with arch braces
St Botolph, Trunch, Norfolk

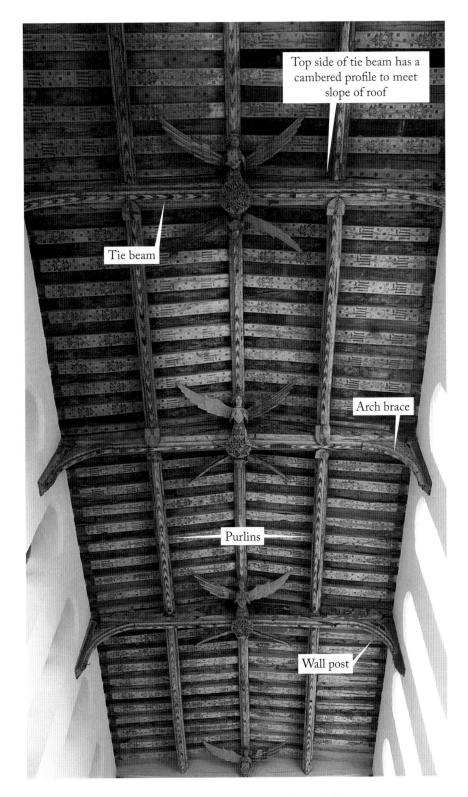

Top side of tie beam has a cambered profile to meet slope of roof

Tie beam

Arch brace

Purlins

Wall post

Cambered tie beam roof with arch braces
Holy Trinity, Blythburgh, Suffolk

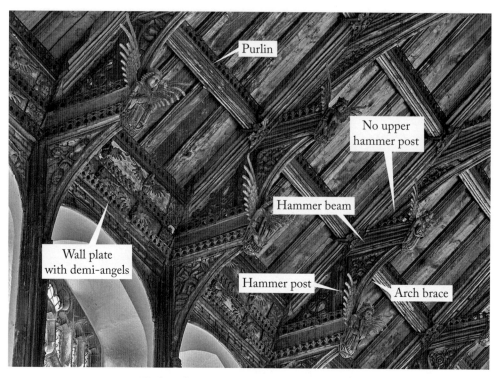

False double hammer beam roof
St Peter and St Paul, Swaffham, Norfolk

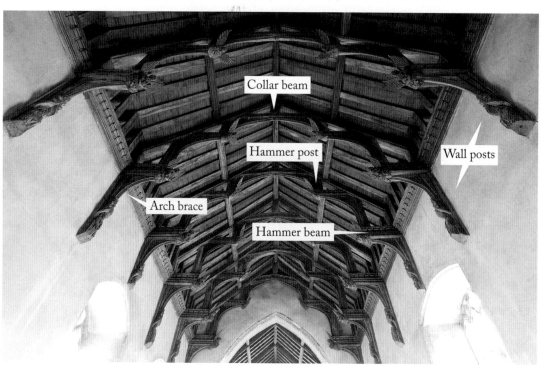

True double hammer beam roof
St Mary, Gissing, Norfolk

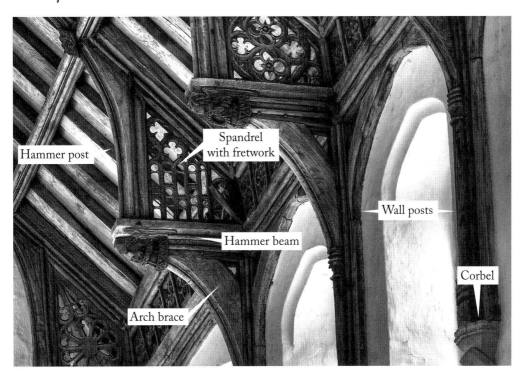

Single hammer beam roof with arch braces
St Botolph, Banningham, Norfolk

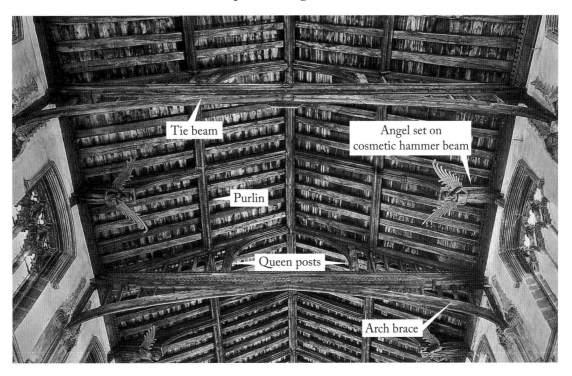

Tie beam and arch-braced roof with "cosmetic" hammer beams
St Nicholas, King's Lynn, Norfolk

Notes

1. The study of England's many medieval parish churches has been fragmented and localized. While many churches have a guidebook of some sort, and excellent regional guides exist (such as the invaluable *The Guide to Norfolk Churches* by D.P. Mortlock and C.V. Roberts, The Lutterworth Press, 2007), there has been no detailed, systematic survey of the entire corpus of medieval English churches and the artworks they contain. Thus, for example, from Paul Binski's "The English Parish Church and its Art in the Later Middle Ages":

 > No one is entirely sure just how many mediaeval parish churches date wholly or in part from the mediaeval period, though a figure in excess of 9000 seems probable. ... [A]n extraordinarily small proportion of churches have been surveyed to the point of generating even an elementary ground plan for them; and the full extent of mediaeval wall painting, stained-glass, and sculpture in parish churches is only beginning to be fathomed.

 (Paul Binski, "The English Parish Church and its Art in the Later Middle Ages: a Review of the Problem", *Studies in Iconography*, Vol. 20, 1999, pp. 1-25.)

2. See, for example, the celebrated Doom at St Peter, Wenhaston, Suffolk. Painted in about 1520 in oils on wood, it shows Christ in Judgment, with St Michael weighing the souls of the departed. On Christ's right, the faithful are admitted to heaven by St Peter, while on His left, the sinful, bound in red hot chains and tormented by demons, are devoured by the mouth of hell. This painting originally sat in the chancel arch and formed a backdrop to the rood; gaps show where the rood sculptures of Christ crucified, flanked by Mary and St John, fitted against it. The Wenhaston Doom was whitewashed over in the Reformation, and only uncovered by accident during the restoration of the church in 1892.

 Other fine medieval wall paintings can be seen in East Anglia at St Mary, Bacton, Suffolk (a fragmentary Judgment scene, with the dead rising from their graves) and at St Ethelbert, Hessett, Suffolk (a fabulous depiction of the seven deadly sins from the 1370s, and a "Sunday Christ" from around 1430 showing the tools of trades that were not to be practised on the Sabbath).

 St Ethelbert also has a fragmentary wall painting of St Christopher over the north door. This saint was particularly popular in medieval churches for it was believed that anyone who looked on St Christopher would be protected against a sudden (and so un-confessed) death that day.

 For a detailed gazetteer of medieval wall paintings across the country and a discussion of their subjects, see Roger Rosewell, *Medieval Wall Paintings in English and Welsh Churches*, Boydell Press, 2008.

3. Lawrence Stone, *Sculpture in Britain: The Middle Ages*, Penguin Books, 1972, p. 2. The actual destruction rate may have been even higher than 90 per cent: "My unscientific sampling of some major buildings suggests that the loss rate is even higher than Stone thought." (Richard Deacon and Phillip Lindley, *Image and Idol: Medieval Sculpture*, Tate Publishing, 2001, p. 39, Note 1.)

4. Deacon and Lindley, *Image and Idol*, p. 37.

5. Angel roofs that are not in churches include Coventry Guildhall, Rufford Hall in Lancashire (this roof is believed to have come from a nearby Priory), Westminster Hall and the roof of Exeter Law Library (dated by its timbers to somewhere between 1417 and 1442).

6. Establishing the total number of surviving angel roofs in England and Wales is not straightforward.

There is no definitive architectural register for parish churches, and Nikolaus Pevsner's forty-two-volume *The Buildings of England* (Cambridge University Press), while useful for roof types (hammer beam, tie beam, etc.), does not have an index entry for angel roofs. The best previous attempt at a comprehensive list that I have seen is that of Dr Dana Bentley-Cranch and Rosalind K. Russell in their monograph *Roof Angels of the East Anglian Churches* (published online at www.roof-angels.org.uk, 2005), but having visited the locations, I have found that this list has several omissions and false inclusions. Using the Bentley-Cranch list as a starting point, I have therefore corrected it for demonstrable errors, and then cross-referenced against a wide range of other works, personal visits and correspondents' accounts to arrive at a total of almost 170 medieval angel roofs in England and Wales (including both roofs where the angels are intact and roofs where the angels were removed or defaced by iconoclasts).

Since there is no definitive register, there may well be other angel roofs that I have missed, although I think such omissions are unlikely to affect the overall geographic pattern.

Of my total, 44 are in Norfolk, 49 are in Suffolk and 24 are in Cambridgeshire. There are a further 12 in Lincolnshire, and another 12 in Bedfordshire, Hertfordshire, Northamptonshire and Essex combined, giving this eight-county "greater" East Anglian region almost 84 per cent of the total.

The small pockets of angel roofs found in North Wales and the West Country are generally of a very different structural type to those in East Anglia. The roofs in Somerset and Devon are either barrel vaulted and coffered (a characteristic West Country design) or use tie beams and king posts in an un-East Anglian form. The North Wales roofs follow distinctive Welsh patterns, such as a stubby hammer beam design (Whitchurch and Llanynys), cambered beams and coffering (Gresford), or arch braces with decorated purlins (Llanrhiadr). Illustrations of these Welsh and West Country roofs can be found in F.E. Howard and F.H. Crossley's *English Church Woodwork*, Batsford, 1917, pp. 110-28.

Judith Bailey at the University of Adelaide kindly drew my attention to an angel roof at Llanidloes in Wales, where one of the angels carries the date 1542, and many carry the symbols of Christ's Passion. This is by far the latest sixteenth-century angel roof of which I am aware and the only one I know of in the area. The fact that it was built eight years after Henry VIII broke with Rome provides fascinating evidence of the differing rates at which the English Reformation took hold around the country, particularly in outlying areas.

7. Hugh Herland (c. 1330-1411) was master carpenter ("disposer of the king's works touching the art or mistery of carpentry") to both Richard II and his predecessor, Edward III. In a career spanning more than fifty years, he worked on Westminster Palace; the Tower of London; Rochester Castle; New College, Oxford; and Winchester College, and may have designed the testers over the tombs of Edward III and Queen Philippa at Westminster Abbey. (See John Harvey, *English Medieval Architects: A Biographical Dictionary*, Alan Sutton Publishing, 1987, pp. 137-41.) By the time he built the roof at Westminster Hall, Herland would have been in his sixties.

8. The much smaller arch rib and hammer beam roof at the Pilgrim's Hall in Winchester predates that at Westminster by over eighty years. Herland is known to have visited Winchester frequently. The design of the Pilgrim's Hall there very probably inspired his use of hammer beams and arch ribs in combination to roof the huge space at Westminster Hall.

Richard II's half-brother John Holland built a major hammer beam roof at Dartington Hall, Devon; work may have begun as early as 1388, but more probably not until the 1390s. See John Steane, *The Archaeology of the Medieval English Monarchy*, Routledge, 1999, p. 78. The Dartington roof, which had a span of 32.5 feet, has not survived.

Some have suggested that the roof of the great hall at Kenilworth Castle, built in the 1370s for John of Gaunt, Richard II's uncle, was a hammer beam roof, but based on an analysis of the hall's relatively intact masonry, Anthony Emery has concluded that it was actually an arch-braced and collared roof. (Anthony Emery, *Greater Medieval Houses of England and Wales: Volume II*, Cambridge University Press, 2000, p. 404.)

9. John Harvey, *The Master Builders: Architecture in the Middle Ages*, Book Club Associates, 1973, p. 104. Elsewhere, Harvey wrote, "It is strange that so little notice is taken of this roof; it is the most outstanding individual work in the whole history of English art, yet it ranks low in the list of London's historic attractions for the visitor. Its true rank is with, or above, the Pyramids, as a Wonder of the World." (John Harvey, "The King's Chief Carpenters", *Architectural Journal*, 3rd Series, Vol. 9, 1948.)

Similarly, William Bryant Logan (*Oak: The Frame of Civilization*, W.W. Norton & Co, 2006, pp. 160-69) has described Herland's roof thus:

> The greatest work of art of the European Middle Ages is not a painting, not a sculpture, not a cathedral. It is 660 tons of oak, the timber-framed roof of Westminster Hall. . . . No [previous] roof was as audacious, as beautiful, or as intelligent as the roof of Westminster Hall. . . . No one had ever before spanned a distance of anything like sixty-eight feet without the use of intermediate posts.

> There is, in fact, one earlier timber roof of greater span (84 feet) than Herland's, at the Palazzo della Ragione in Padua, northern Italy. Believed to have been designed in about 1306 by an Austin friar, frate Giovanni, it is functional rather than beautiful, and relies on iron tie rods for rigidity. This Paduan roof is not a hammer beam roof.

10. For the estimated weight of the timbers and lead in the roof, and for a graphic account of the extent to which the timbers had decayed by the time restoration began in 1914, see Herbert Cescinsky and Ernest R. Gribble, "Westminster Hall and its Roof", *Burlington Magazine*, Vol. 40, No. 227, Feb. 1922.

11. In his preliminary structural report, Sir Frank Baines, who restored the roof between 1914-23, recorded that four of the thirteen trusses were in danger of collapse, the wall posts almost all no longer bearing thrust and the footings of some of the principal rafters eaten away, and that beetles had eaten out cavities in which "a full grown man could lie completely hidden from sight". (Dorian Gerhold, *Westminster Hall: Nine Hundred Years of History*, James & James, 1999, p. 68.)

12. Logan, *Oak: The Frame of Civilization*, p. 168

13. L.F. Salzman, *Building in England Down to 1540*, Clarendon Press, 1992, p. 29.

14. A. Goodman and J.L. Gillespie (eds.), *Richard II: The Art of Kingship*, Oxford University Press, 2003, p. 150.

15. Thus, for example, the will of John Baret (d. 1467), a rich Suffolk clothier who endowed the magnificent angel roof of St Mary, Bury St Edmunds:

> Item, I will that there be found a priest at my expense once a year to sing in Saint Mary's church *for the souls whose bodies I have caused to lose silver in any way in my life at any time, and for all the souls of all the persons . . . that ever I meddled with or had of any silver or good, small or large, or deluded by any means.*

(Samuel Tymms (ed.), *Wills and Inventories from the Commissary of Bury St Edmunds and the Archdeacon of Sudbury*, Camden Society, 1850, p. 38.) The translation into modern English is mine.

16. Birkin Haward, *Suffolk Medieval Church Roof Carvings*, Suffolk Institute of Archaeology and History, 1999, p. 1 and p. 170. Haward searched the forty-two volumes of Pevsner's *The Buildings of England* using the excellent CD compendium to Pevsner complied by Michael Good.

17. Herland may subsequently have had some involvement in repairs to Kingston Bridge in 1400, but this is not certain. (Harvey, *English Medieval Architects*, p. 140.)

18. The biographical details for Hugh atte Fenn and William Oxeneye come from their entries in *The History of Parliament Online*: www.historyofparliamentonline.org. The website is an online version of *The History of Parliament: the House of Commons 1386-1421*, edited by J.S. Roskell, L. Clarke and C. Rawcliffe, Boydell and Brewer, 1993.

I have been unable to discover anything about Robert atte Fenn (Hugh's brother?) or John de Cleye, though the latter's name implies that he or his family originally came from Cley-next-the-Sea in North Norfolk. Cley was a centre of shipbuilding. The ship co-owned by Hugh atte Fenn and William Oxeneye is known to have been built there.

It is likely that Robert atte Fenn and John de Cleye were also members of the wealthy Yarmouth governing and mercantile elite, though they seem never to have represented the town at Parliament.

19. The information on William Oxeneye of King's Lynn is to be found in the *History of Medieval Lynn*: http://users.trytel.com/~tristan/towns/lynn1.html.

20. I am indebted to Dr Margit Thofner at the University of East Anglia for highlighting the likely importance of shipwrights in East Anglia as a factor in the region's roof carpentry expertise.

21. Competition is a clear and recurrent theme in surviving medieval building contracts, which often specify that the work is to be "as good as or better than" the work at a nearby location. See P. Lindley, *Gothic to Renaissance: Essays on Sculpture in England*, Paul Watkins of Stamford, 1995, p. 33; and Salzman, *Building in England*, Appendix B.

22. A 1419 will donation to St Nicholas, King's Lynn, referring to the church as *"de novo aedificato"* ("newly built"), forms part of the basis for dating the angel roof there to early in the fifteenth century. An eye witness account of a window at St Nicholas bearing the date 1413 – now vanished – pushes the date back further to c. 1405-10. A dendrochronological survey of part of the roof at St Nicholas which was undertaken by the Oxford Dendrochronology Laboratory (ODL) in 2015 indicated a date range for the timbers tested in the late 1390s-early 1400s. I am indebted to Dr Martin Bridge at ODL for sharing the report with me.

23. *The History of Parliament Online*. Wace was a member of the Holy Trinity merchants' guild and returned to Parliament once, in January 1390. In the same year, he imported dried fish, tar, timber, iron, pelts and wax from Scandinavia and the Baltic valued at over £210. In 1392, he exported cloth and malt to the value of £145. These are very large sums.

24. "For the vast majority of parish churches, there are no medieval fabric rolls or building accounts, and no recorded dates that can be linked to the structure or to the fittings." Warwick C. Rodwell, *The Archaeology of Churches*, Amberley Books, 2012, p. 56. Only a small number of medieval building contracts have survived. According to Rodwell, L.F. Salzman (in his great work *Building in England*) "was only able to find twenty relating to churches". (Rodwell, *The Archaeology of Churches*, p. 58.)

Fascinatingly, one of these twenty is a 1452 contract (not a construction inventory) for the angel roof at St Benet in Cambridge, made between carpenter "Nicholas Toftys of Reche in the shire of Cambrigg" and the church reeves, or works administrators, Thomas Byrd and Thomas Wrangyll, "otherwise called Thomas Richardesson". It sets out the number and dimensions of the beams and boards to be used, specifies decorative features (beams were to be "inbowed with lozinggys" – carved with lozenges), stipulates that some components are to be made from "summer trees convenient unto the work" and includes the following:

> Item atte euery joynt of the Crest tre atte the Principalls and sengulers shalbe half Angells.
> Also atte euery joynt of the sommere trees shalhaue a boos.
> Item atte euery end of the pendaunt shalbe a angell.

Item atte euery end of the sengulers ate the Jowpye shalbe an Angel.

In witnesse were of the partyes a forseyd to theis present indenturys there selys ich to othere hath putt. Yeuyn the day yere and place before seyd etc.

In modern English:

> Item at every joint of the ridge-piece of the roof at the principal and secondary rafters shall be half angels.
> Also every joint of the summer trees shall have a boss.
> Item at every end of the pendant shall be an angel.
> Item at every end of the secondary rafters at the cornice shall be an angel.
> In witness whereof the aforesaid parties have put their respective seals to this present indenture. Given the day, year [June 6th, 1452] and place before said, etc.

The above translation is mine. The full agreement appears in Salzman's *Building in England*, p. 530-31. Salzman himself is citing it from Volume I of Robert Willis and John Willis Clark's *Architectural History of the University and Colleges of Cambridge,* published in 1886 by the Cambridge University Press.

The agreement does not contain a price for the work, but from other contracts we know that the normal format specified an overall price, with a partial payment upfront, followed by stage payments as the work progressed and a target completion date – much like modern building contracts. Contracts were struck with the master carpenter, who would then be responsible for paying the wages of his workmen. Thus, for example, a contract from 1415 for a roof at Harley Wintney Church in Hampshire specifies that £10 was to be paid on commencement, £6 when the timber had been framed and a further £6 when the roof had been erected. (Salzman, *Building in England*, p. 52.)

Little remains of the original roof at St Benet. The church was the victim of heavy-handed Victorian remodelling.

25. Salzman, *Building in England*, pp. 218-9.
26. See for example, H. Munro Cautley, *Suffolk Churches and Their Treasures*, Norman Adlard & Co., 1937, p. 84; and Paul N. Hasluck (ed.), *Manual of Traditional Woodcarving*, Dover Publications, 1977.

27. The fifteenth-century building boom – evidenced in the rebuilding of churches, and the commissioning of merchant guildhalls and flashily timbered houses for the well-to-do – made constructional timber increasingly expensive. Domestic building accounts show significant inflation in timber prices between the fourteenth and fifteenth centuries. Large amounts of timber, generally in the form of boards, were imported into England from Northern Europe from the late fourteenth century onwards. (Salzman, *Building in England*, p. 209 and p. 245.)

28. Gerhold, *Westminster Hall: Nine Hundred Years of History*, p. 20.

29. For example, a contract from 1436 for the building of a house in Winchester states "the work to be made as the tracing drawn on a parchment skin shows". Similarly a carpenter's contract for work at Hertford Castle in 1380 refers to "une patron endentée" – a plan in duplicate. (Salzman, *Building in England*, p. 584 and p. 459.)

30. Only one such collection of drawings survives. It dates from about 1230, and is the work of Villard de Honnecourt, a native of Picardy in northern France. Honnecourt is generally thought to have been a travelling mason or carpenter. The collection contains architectural drawings (including roof structures) in plan and elevation, human and animal figures, sculptural designs and mechanical devices. (*Album de Villard de Honnecourt*, Bibliothèque Nationale, Paris.)

31. Grants to Herland in 1396 gave him for life "the little house lying in the outer little ward of the palace of Westminster . . . for keeping his tools and for making his models and moulds for his carpentry work". The house had originally been made available to him by Edward III thirty years earlier. (Harvey, *English Medieval Architects*, p. 140.)

32. The only manuscript of *The Debate of the Carpenter's Tools* is in the Bodleian Library (*Codex Ashmole 61*). The spelling forms used suggest that it was written in north east Leicestershire, and it is generally dated to the late fifteenth century. The manuscript is in a "holster book" format suitable for carrying around so that it could be read out, and the poem is so specific to the craft of woodworking that it was probably intended for recitation to a knowing audience at carpenters' trade celebrations. See Edward Wilson, "The Debate of the Carpenter's Tools", *Review of English Studies*, Vol. 38, Issue 152, 1987.

33. Logan, *Oak: The Framework of Civilization*, p. 56.

34. Such pre-emption rights were part of the royal prerogative of *prise*. In 1253, Henry III instructed his clerk of works to make sure that a building project was completed before Easter "even though it should be necessary to hire a thousand workmen a day for it". (Salzman, *Building in England*, pp. 36-7.)

35. It has been reckoned that by 1450 about half of the finished cloth manufactured in Bury St Edmunds in Suffolk was shipped out of King's Lynn in north Norfolk, transported there via the rivers Lark and Great Ouse.

 See also Salzman, *Building in England*, p. 349. "So far as possible water carriage was employed for the transport of stone and heavy timber."

36. The roof at Knapton is a double hammer beam with "collars" – ties that connect the main rafters at a level close to the roof apex. Collars, as Birkin Haward notes in *Suffolk Medieval Church Roof Carvings*, are rare in Norfolk roofs, but common in Suffolk, lending credibility to the idea that Knapton's roof was made there and transported to Norfolk.

37. See Haward, *Suffolk Medieval Church Roof Carvings*, p. 126 and p. 30. Haward notes that "false" double hammer beam roofs ("false" because the upper tier of hammer beams is not connected to the rafters by a vertical hammer post, and so is not load bearing) – of which St Wendreda in March, Cambridgeshire, is an example – are most prevalent around Bacton in Suffolk. "It must surely be significant that these Suffolk false double hammerbeam roofs occur only at Bacton, Woolpit, Cotton, Shotley, Rattlesden, Gislingham, Tostock and Wetherden, all, with the exception of Shotley, located in a close group just East of Bury." On the basis of similarities in design and carving between the roofs in the Bacton area and the roof at March, Haward argues that it was probably made in a workshop in or near Bacton.

38. In concealed roof spaces, medieval lifting gear was sometimes left in place once the building had been completed, presumably because it was easier than dismantling it and carrying the pieces back to ground level. There is a medieval treadmill in the spire of Salisbury Cathedral and an abandoned crane in the internal roof space at Canterbury. The Canterbury crane was still used by cathedral workmen until the 1970s!

39. See Cautley, *Suffolk Churches and their Treasures*, p. 89.

40. Basing his analysis on hammer beam roof entries in Pevsner's *Buildings of England*, Birkin Haward found that over 70 per cent of all surviving medieval

hammer beam roofs (whether single or double hammer beams) are located in Norfolk, Suffolk, Cambridgeshire and Essex. Haward's figures are 124 out of 188 (65.9 per cent) for single hammer beams, 32 out of 32 for double hammer beams and 156 out of 220 (70.9 per cent) for hammer beams of either type. (Haward, *Suffolk Medieval Church Roof Carvings*, p. 170.)

41. Rodwell, *The Archaeology of Churches*, p. 56.

42. For biographical details on William de Berdewell, see D.P. Mortlock's *The Guide to Suffolk Churches*, The Lutterworth Press, 2009, p. 33; and *The History of Parliament Online* (www.historyofparliamentonline.org). A photograph of the donor window portrait of Sir William in his armour can be found on my website, *The Angel Roofs of East Anglia*: www.angelroofs.com/william-de-berdewell.

43. For an examination of Norfolk will evidence, see Paul Cattermole and Simon Cotton, "Medieval Parish Church Building in Norfolk" in *Norfolk Archaeology*, Vol. 38, 1983, pp. 235-79.

44. See Haward, *Suffolk Medieval Church Roof Carvings*, pp. 173-82. Haward used a combination of local records and East Anglian entries in John Harvey's *English Medieval Architects* to construct his list.

45. See note 24 for details of the St Benet's angel roof contract.

46. The church guide at St Wendreda suggests that the roof was made by the Rollesby brothers of Bacton (active c. 1421-51), but I am not aware of any concrete evidence on which to base an attribution to these – or any other – named carpenters.

47. John Harvey, *Mediaeval Craftsmen*, Batsford, 1975, p. 152; Haward, *Suffolk Medieval Church Roof Carvings*, p. 176.

48. By the end of his career, Herland's position, even as the royal carpenter, was quite exceptional. He earned £43 3s 4d in 1397 as Chief Carpenter of the King's Works. The normal fee for this position stood at £18 5s from the time of Edward I until the sixteenth century. See Harvey, *English Medieval Architects*, Appendix II.

49. Harvey, *Mediaeval Craftsmen*, pp. 147-58; Salzman, *Building in England*, pp. 75-6.

50. Harvey, *English Medieval Architects*, p. 7 and p. 82.

51. Lindley, *Gothic to Renaissance*, p. 7 and p. 11.

52. See Haward, *Suffolk Medieval Church Roof Carvings*, Appendix 10.2.

53. See David King's essay "Medieval Art in Norfolk and the Continent" in David Bates and Robert Liddiard (eds.), *East Anglia and its North Sea World in the Middle Ages,* Boydell Press, 2013, pp. 103-5. King suggests that the Dutchman Robert Mundeford may have been responsible for the exquisitely carved chancel bosses at Salle Church in Norfolk which depict the life of Christ.

54. Salzman, *Building in England*, pp. 218-9.

55. For Richard Aleyn of Bury St Edmunds, see Haward, *Suffolk Medieval Church Roof Carvings*, p. 173.

56. Lindley, *Gothic to Renaissance*, pp. 28-9.

57. See Harvey, *Mediaeval Craftsmen*, pp. 164-5.

58. I am greatly indebted to Richard Barton-Wood at Wymondham for his observations regarding the use of colour there, and for prompting me to re-evaluate the overall evidence for the use of colour in angel roofs.

59. Mildred Holland was advised by E.L. Blackburne FSA, who was considered – at the time – an expert in medieval decoration. Building accounts from 1865 detail the commissioning of the roof angels: "Mr Spall's extras included 8 angels with expanded wings, Chancel, £12. B.W. Spall, time and materials to preparing and fixing 10 angels, £80." Huntingfield lies to the north west of Ipswich, off the B1117. The church is open daily and has an excellent website at www.stmaryshuntingfield.org.uk. As it is a non-medieval angel roof, I have excluded it from the map and gazetteer section of this book.

60. In addition to the well-known cycles of mystery plays, there was a long established tradition of liturgical plays – dramatized reconstructions of episodes from scripture – in churches. The first record of such enactments in England occurs in the tenth-century *Concordia Regolaris* which stipulates how the dialogue between the angel and the holy women at Christ's empty tomb is to be presented. A document detailing the gift of an Easter sepulchre to St Mary Redcliffe, Bristol, in 1470 includes angel wings and wigs (!) to be worn by the re-enactors around the tomb. See M.D. Anderson, *Drama and Imagery in English Medieval Churches*, Cambridge University Press, 1963, pp. 26-8.

61. Such depictions echo the appearance of the instruments of Christ's Passion foretold in *The Golden Legend*, a hugely influential collection of saints' lives and liturgical instruction compiled in the 1260s by the Dominican friar Jacobus de Voragine. *The Golden Legend* circulated widely in England in *manuscript* form from the late thirteenth century and became, in effect, a medieval bestseller. It influenced the South English Legendary vernacular of the late 1200s

and was clearly known to Chaucer and Langland. The first *printed* edition in English was Caxton's translation of 1483.

Volume I of *The Golden Legend* describes how the instruments of the Passion will appear in the heavens to mark the second coming of Christ:

> The third thing that followeth the Judgement, that shall be the signs and tokens of the passion of Jesus Christ. That is, to wit, the cross, the nails and the wounds. The which signs shall be first for to shew His glorious victory.

62. Anderson, *Drama and Imagery in English Medieval Churches*, p. 169.

63. See F. Taylor and J.S. Roskell (trans. and eds.), *Gesta Henrici Quinti: The Deeds of Henry the Fifth*, Oxford Medieval Texts, 1975, pp. 106-11; and Thomas Elmham's "Liber Metricus de Henrico Quinto", in Charles Augustus Cole (ed.), *Memorials of Henry the Fifth, King of England*, Longman, 1858, p. 127.

64. I am greatly indebted to Michael Begley of King's Lynn for providing me with these references to mechanical and censing angels in medieval East Anglia. The Corpus Christi angels are to be found in the Lynn Borough Archives, KL/C7/3 fo.155v. The Norwich censing angel is mentioned in W. Page (ed.), *The Victoria County History of Norfolk*, Vol. 2, James Street, 1906, p. 322. The source for the angels at St Margaret, King's Lynn, is the will of Thomas Goisman of Kingston upon Hull, dated October 1502, in which Goisman left money to make a set of angels like those at Lynn for his own church of Holy Trinity, Hull.

On the subject of medieval automata, some churches were not above using mechanical artifice to gull the faithful. When iconoclasts destroyed a famous rood sculpture at Boxley in Kent that had become an object of pilgrimage and veneration, they found that it contained "certain engines and old wire, with old rotten sticks in the back . . . that did cause the eyes of the same to move . . . and also the nether lip . . . to move as though it should speak" (G.H. Cook, *Letters to Cromwell and Others on the Suppression of the Monasteries*, John Baker, 1965, p. 144); and in a sermon on the sin of idolatry in 1547, Bishop William Barlow displayed an image of Christ from an Easter sepulchre "which putt out his legges . . . and blessed with his hand, and turned his heade" (Margaret Aston, *Faith and Fire: Popular and Unpopular Religion, 1350-1600*, Hambledon Press, 1993, p. 282).

65. W.G. Constable, "Introduction" in M.D. Anderson, *The Medieval Carver*, Cambridge University Press, 1935, p. xvii.

66. The notion of a guardian angel appears explicitly in the New Testament (Matthew 18:10, Acts 12:15) and in the Apocryphal Book of Tobit, in which Tobit's son Tobias is guided by the angel Raphael in human form.

The popular twelfth-century theologian Honorius Augustodunensis (d. 1151), who studied under Anselm of Canterbury, asserted that an angel is assigned to each human soul at birth.

67. Herbert of Losinga (d. 1119) founded Norwich Cathedral in 1096, while Bishop of Thetford. He subsequently transferred his see to Norwich, becoming its first bishop. Losinga also founded the churches of St Nicholas in Great Yarmouth, St Margaret in King's Lynn, and Norwich School.

68. *Savoy Hours* folio 5, recto. (Beinecke Rare Book and Manuscript Library, Yale University); *Hours of Francesco Sforza*, c. 1490 (British Library).

69. Trevor Cooper (ed.), *The Journal of William Dowsing: Iconoclasm in East Anglia During the English Civil War*, Boydell Press, 2001, pp. 25-6.

70. "9 May 1644: An Ordinance for the further demolishing of Monuments of Idolatry and Superstition" in C.H. Firth and R.S. Rait (eds.), *Acts and Ordinances of the Interregnum, 1642-1660*, HMSO, 1911, pp. 425-6.

71. John Morrill, "William Dowsing and the administration of iconoclasm" in Trevor Cooper (ed.), *The Journal of William Dowsing: Iconoclasm in East Anglia during the English Civil War*, Boydell Press, 2001, p. 7 and p. 11.

72. *ibid.*, p. 15.

73. See John Blatchly, "In search of bells: iconoclasm in Norfolk, 1644" in Cooper (ed.), *The Journal of William Dowsing*, pp. 107-22.

74. Cooper (ed.), *The Journal of William Dowsing*, p. 155.

Bibliography

Anderson, M.D., *The Medieval Carver*, Cambridge University Press, 1935

——, *Drama and Imagery in English Medieval Churches*, Cambridge University Press, 1963

Aston, Margaret, *Faith and Fire: Popular and Unpopular Religion, 1350-1600*, Hambledon Press, 1993

Bailey, Mark, *Medieval Suffolk: An Economic and Social History 1200-1500*, Boydell Press, 2007

Cole, Charles Augustus (ed.) *Memorials of Henry the Fifth, King of England*, Longman, 1858

Cook, G.H., *Letters to Cromwell and Others on the Suppression of the Monasteries*, John Baker, 1965

Bates, David and Liddiard, Robert (eds.), *East Anglia and its North Sea World in the Middle Ages*, Boydell Press, 2013

Bentley-Cranch, Dana and Marshall, Rosalind K., with Mayer, Edward, *Roof Angels of the East Anglian Churches*, 2005 (published online at www.roof-angels.org.uk)

Bernard, G.W., *The Late English Medieval Church: Vitality and Vulnerability Before the Break with Rome*, Yale University Press, 2012

Binski, Paul, "The English Parish Church and its Art in the Later Middle Ages: a Review of the Problem", *Studies in Iconography*, Vol. 20, 1999, pp. 1-25

Blair, John and Ramsey, Nigel (eds.), *English Medieval Industries*, Hambledon Press, 1991

Blomefield, Francis, *An Essay Towards a Topographical History of the County of Norfolk*, 1805

Brandon, Raphael and Brandon, J. Arthur, *Masterpieces of Medieval Open Timber Roofs*, London, 1849 (republished by Dover Editions, 2005)

Braun, Hugh, *English Mediaeval Architecture*, Bracken Books, 1985

Burton, Peter and Walshaw, Harland, *The English Angel*, Windrush Press, 2000

Cattermole, Paul and Cotton, Simon, "Medieval Parish Church Building in Norfolk", *Norfolk Archaeology*, Vol. 38, 1983

Cattermole, Paul (ed.), *Wymondham Abbey: A History of the Monastery and Parish Church*, Wymondham Abbey 2007 Book Committee, 2007

Cautley, H. Munro, *Suffolk Churches and Their Treasures*, Norman Adlard & Co., 1937

——, *Norfolk Churches*, Norman Adlard & Co., 1949

Cescinsky, Herbert and Gribble, Ernest R., *Early English Furniture and Woodwork*, Routledge and Sons, 1922

——, "Westminster Hall and its Roof", *Burlington Magazine*, Vol. 40, No. 227, Feb. 1922

Chase, Stephen (trans. and intro.), *Angelic Spirituality: Medieval Perspectives on the Ways of Angels*, Paulist Press, 2002

Coldstream, Nicola, *Medieval Craftsmen: Masons and Sculptors*, University of Toronto Press, 1991

Colvin, H.M., *English Architectural History: A Guide to Sources*, Pinhorns, 1976

Cooper, Trevor (ed.), *The Journal of William Dowsing: Iconoclasm in East Anglia during the English Civil War*, Boydell Press, 2001

Courtenay, L.T., "The Westminster Hall Roof and its 14th Century Sources", *Journal of the Society of Architectural Historians*, Vol. 43, No. 4, Dec. 1984

—— and Mark, R., "The Westminster Hall Roof: A Historiographic and Structural Study", *Journal of the Society of Architectural Historians*, Vol. 46, No. 4, Dec. 1987

Crook, John, "The Pilgrims' Hall, Winchester: Hammerbeams, Base Crucks and Aisle-Derivative Roof Structures", *Archaeologia*, Vol. 119, 1991

Crossley, F.H., *Timber Building in England*, Batsford, 1951

Curry, Anne and Matthew, Elizabeth (eds.), *Concepts and Patterns of Service in the Later Middle Ages*, Boydell Press, 2000

Deacon, Richard and Lindley, Phillip, *Image and Idol: Medieval Sculpture*, Tate Publishing, 2001

Duffy, Eamon, *The Stripping of the Altars: Traditional Religion in England 1400-1580*, Yale University Press, 2005

Emery, Anthony, *Greater Medieval Houses of England and Wales, 1300-1500, East Anglia, Central England and Wales, Volume II*, Cambridge University Press, 2000

Faleer, Robert A., *Church Woodwork in the British Isles, 1100-1535*, Scarecrow Press, 2009

Firth, C.H. and Rait, R.S. (eds.), *Acts and Ordinances of the Interregnum, 1642-1660*, HMSO, 1911

Fitchen, John, *Building Construction Before Mechanization*, The MIT Press, 1989

Gardner, Arthur, *English Medieval Sculpture*, Cambridge University Press, 1951

——, *Minor English Wood Sculpture 1400-1550*, Alec Tiranti, London, 1958

Gerhold, Dorian, *Westminster Hall: Nine Hundred Years of History*, James & James, 1999

Gibson, Gail McMurray, *The Theater of Devotion: East Anglian Drama and Society in the Late Middle Ages*, University of Chicago Press, 1994

Gilchrist, Roberta, *Medieval Life: Archaeology and the Life Course*, Boydell Press, 2012

Goodman, A. and Gillespie, J.L. (eds.), *Richard II: The Art of Kingship*, Oxford University Press, 2003

Gottfried, Robert S., *Bury St Edmunds and the Urban Crisis 1290-1539*, Princeton University Press, 1982

Harper-Bill, Christopher (ed.), *Medieval East Anglia*, Boydell Press, 2005

Harvey, John, "The King's Chief Carpenters", *Architectural Journal*, 3rd Series, Vol. XI, 1948

——, *The Master Builders: Architecture in the Middle Ages*, Book Club Associates, 1973

——, *Mediaeval Craftsmen*, Batsford, 1975

——, *English Medieval Architects*: *A Biographical Dictionary*, Alan Sutton Publishing, 1987

Hasluck, Paul N. (ed.), *Manual of Traditional Woodcarving*, Dover Publications, 1977

Haward, Birkin, *Suffolk Medieval Church Roof Carvings*, Suffolk Institute of Archaeology and History, 1999

——, *Master Mason Hawes of Occold, & John Hore, Master Carpenter of Diss*, Suffolk Institute of Archaeology and History, 2000

Hewett, Cecil A., *English Historic Carpentry*, Phillimore & Co. Ltd., 1980

Hicks, Michael, *English Political Culture in the Fifteenth Century*, Routledge, 2002

Horrox, Rosemary (ed.), *Fifteenth-Century Attitudes*, Cambridge University Press, 2008

Howard, F.E. and Crossley, F.H., *English Church Woodwork*, Batsford, 1917

Ives, Eric, *The Reformation Experience*, Lion Hudson, 2012

Keck, David, *Angels and Angelology in the Middle Ages*, Oxford University Press, 1998

Keen, Maurice, *England in the Later Middle Ages*: *Second Edition,* Routledge, 2003

Lindley, Phillip, *Gothic to Renaissance: Essays on Sculpture in England*, Paul Watkins of Stamford, 1995

Logan, William Bryant, *Oak: The Frame of Civilization*, W.W. Norton & Co., 2006

MacKinney, Lisa, "Rosaries, Paternosters and Devotion to the Virgin in the Households of John Baret of Bury St Edmunds", *Parergon*, Vol. 24, No. 2, 2007

Marks, Richard, *Image and Devotion in Late Medieval England*, Sutton Press, 2000

Morris, Toby E.; Black, Gary R.; Tobriner, Stephen O., "Report on the Application of Finite Element Analysis to Historic Structures: Westminster Hall", *Journal of the Society of Architectural Historians*, Vol. 54, No. 3, Sep. 1995

Mortlock, D.P. and Roberts, C.V., *The Guide to Norfolk Churches*, The Lutterworth Press, 2007

Mortlock, D.P., *The Guide to Suffolk Churches*, The Lutterworth Press, 2009

Nichols, Ann Eljenholm, *Seeable Signs: The Iconography of the Seven Sacraments, 1350-1544*, Boydell Press, 1994

Page, W. (ed.) *The Victoria County History of Norfolk*, Vol. 2, James Street, 1906

Pevsner, Nikolaus, *The Buildings of England: Cambridgeshire*, Yale University Press, 2002

—— and Radcliffe, Enid, *The Buildings of England: Suffolk,* Yale University Press, 2002

—— and Wilson, Bill, *The Buildings of England – Norfolk 1: Norwich and North-East*, Yale University Press, 2002

—— and Wilson, Bill, *The Buildings of England – Norfolk 2: North-West and South*, Yale University Press, 2002

Rodwell, Warwick C., *The Archaeology of Churches*, Amberley Books, 2012

Roffey, Simon, *Chantry Chapels and Medieval Strategies for the Afterlife*, Tempus Publishing, 2008

Rosewell, Roger, *Medieval Wall Paintings in English and Welsh Churches*, Boydell Press, 2008

Sager, Peter, *East Anglia: Essex, Suffolk & Norfolk*, Pallas Guides, 1994

Salzman, L.F., *Building in England Down to 1540*, Clarendon Press, 1992

Spraggon, Julie, *Puritan Iconoclasm in the English Civil War*, Boydell Press, 2003

Statham, Margaret, "John Baret of Bury", *The Ricardian*, Vol. 13, 2003

Steane, John, *The Archaeology of the Medieval English Monarchy*, Routledge, 1999

Stone, Lawrence, *Sculpture in Britain: The Middle Ages*, Penguin Books, 1972

Taylor, F. and Roskell, J. S. (trans. and ed.), *Gesta Henrici Quinti: The Deeds of Henry the Fifth*, Oxford Medieval Texts, 1975

Tolhurst, J.B.L., "Hammerbeam Figures of St Mary's Church, Bury St Edmunds", *Journal of the British Archaeological Association*, Vol. 25, 1962

Tymms, Samuel, *Wills and Inventories from the Registers of the Commissary of Bury St Edmunds and the Archdeacon of Sudbury*, Camden Society, 1850

Voragine, Jacobus de, *The Golden Legend: Selections*, translated by Christopher Stace, Penguin Classics, 1998

——, *The Golden Legend*, translated by W.G. Ryan, Princeton University Press, 2012

Waddell, Gene, "The Design of the Westminster Hall Roof", *Architectural History*, Vol. 42, 1999

Wells, Calvin, "Fifteenth Century Wood Carvings in St Mary's Church, Bury St Edmunds", *Journal of Medical History*, July 1965

Whittock, Martyn, *A Brief History of Life in the Middle Ages*, Constable & Robinson, 2009

Willis, Robert and Clark, John Willis, *Architectural History of the University and Colleges of Cambridge*, Cambridge University Press, 1886

Wilson, Edward, "The Debate of the Carpenter's Tools", *Review of English Studies*, Vol. 38, Issue 152, 1987

Zwerger, Klaus, *Wood and Wood Joints: Building Traditions in Europe, Japan and China*, Birkhäuser, Basle, 2012

Index

*Locations with photographic entries are shown in **bold**.*

You may be interested in

The Guide to Norfolk Churches

By D.P. Mortlock and C.V. Roberts

ISBN: 978 0 7188 3064 9

The profusion of medieval churches in Norfolk not only provides examples of beautiful church architecture, but also records life in their communities and offers an insight into the history of medieval England. Previously published as a three-volume series, this invaluable and straightforward guide to the 'living' medieval churches of Norfolk has been re-written to help the visitor to understand both the general features and the unique of those in different areas.

Written by enthusiasts for both the churches and the county in which they stand, the great appeal of this guide is that, once the code of church architecture has been broken and the language learned, every church, be it ever so humble, is shown to be unique, with its own story to offer. This guide provides the key.

The Guide to Suffolk Churches

By D.P. Mortlock

ISBN: 978 0 7188 3076 2

Suffolk is a county renowned for the beauty of its many parish churches, but for many visitors the physical language in which they speak, that of stained glass, engraved fonts, and hammer-beamed roofs, is obscure. Now available in a single updated volume, *The Guide to Suffolk Churches* provides a route into this fascinating world, its architecture and history.

Written in a voice as knowledgeable as it is enthusiastic about Suffolk and its churches, the guide is incomparable in both its thoroughness and charm, as it unlocks more than 1,000 years of history across the county's hundreds of churches. There is no visit to any parish church in Suffolk, no matter how well informed the visitor, that would not be more enjoyable and informative for having Mortlock along.

Available now with more excellent titles in Paperback, Hardback, PDF and Epub formats from The Lutterworth Press.

www.lutterworth.com